SACRED IMAGES

SACRED IMAGES
A Vision of Native American Rock Art

Text by Leslie Kelen and David Sucec
Foreword by N. Scott Momaday
Photographs by Craig Law, John Telford,
Tom Till, and Philip Hyde

GIBBS·SMITH
P
PUBLISHER

Salt Lake City

First edition

99 98 97 96 5 4 3 2 1

This is a Peregrine Smith Book, published by
Gibbs Smith, Publisher
P.O. Box 667
Layton, UT 84041

Design by Scott Van Kampen

Printed in Hong Kong

Front cover photograph: *Crowned Figure with Familiar,* © 1996 by Craig Law

Back cover photograph: *Skeleton Shaman,* © 1996 by Craig Law

Library of Congress Cataloging-in-Publication Data

Sacred images: a vision of
Native American rock art / text by Leslie Kelen and David Sucec ;
photography by Craig Law . . . [et al.]. —1st ed.

p. cm.

Includes bibliographical references.

ISBN 0-87905-734-3

1. Indians of North America—Utah—Antiquities.
2. Rock paintings—Utah. 3. Picture-writing—Utah. 4. Petroglyphs—Utah.
5. Utah—Antiquities. I. Sucec, David. II. Title.

E78.U55K38 1996

709'.01'1309792—dc20

95-53282

CIP

"The highest truths,
which would not be communicable or
transmissible by any other means, can
be communicated up to a certain
point when they are, so to speak,
incorporated in symbols, which will hide
them for many, no doubt, but which
will manifest them in all their
splendour to the eyes of those
who can see."

* * * * *

RENÉ GUÉNON

from *Fundamental Symbols:*
The Universal Language of Sacred Science

We would like to thank the
George S. and Dolores Doré Eccles,
the Herbert I. and Elsa B. Michael,
and the Ruth Eleanor
and John Ernest Bamberger Foundations,
the Utah Statehood Centennial Commission,
as well as First Security Bank,
Utah Power,
the Salt Lake County Centennial Committee,
and a host of private donors
for providing the funds to make this
project possible.

CONTENTS
* * * * *

Foreword

Prehistoric art, especially rock paintings and engravings, is of special interest to me, and I believe that it is an essential element in the determination and appreciation of our human experience. As a painter, I am concerned to understand the relationship between the artist and his subject, for that relationship is ancient and sacred. To understand that relationship, even imperfectly, gives us a way to find our place in the world, to reckon the course of our journey from birth to death and from Genesis to the edge of time and beyond. As a writer, I am fascinated by language, and I am aware that drawing and painting—the act of setting an image upon a plane—is primarily an expression, an assertion of language. A basic definition of the verb *write* is "to incise as on a surface." The paintings and engravings that we see on these pages are a kind of writing, the earliest writing that we know of on this continent. They are at once the beginning of art in America and the origin of American literature. The artists of Barrier Canyon were telling stories.

A few days ago I passed through a small green door on a hillside in Cantabria, Spain. It was a passage from time into timelessness. On the ceiling of a chamber in the Altamira caves are paintings that are more than 15,000 years old. They are paintings of animals—bison, boar, horse, deer, goat. You look at them and you know that they were placed there by an artist or artists who loved them, in whom they inspired wonder and awe and reverence. As much as did the buffalo and the horse to the Plains Indian of the nineteenth century, they extended his human being to the center of wilderness, of mystery, of deepest life itself. Like the paintings of the greatest artists of every age, they are so fundamental as to be profound.

[At Altamira] what we really discover is our own childhood, we discover ourselves [because we observe] the same essential aspirations in the depths of our souls.
—Teilhard de Chardin

Picasso once declared that he had spent a lifetime learning how to paint like a child. Lewis Thomas believed that language was invented by children. I like to think that the first person to touch pigment to a wall of rock was a child. Such things are, in the best sense, child's play.

From whatever point of view, we perceive in this ancient art the first realization of art itself, and in our blood we remember our earliest experience of form, symmetry, color, depth, perspective—of beauty—and we are made again the whole and immediate gift of wonder and astonishment and delight.

And that gift of the dawn of art is made to us at Barrier Canyon, at Book Cliffs, in the Malpais, and throughout the American Southwest, where the proliferation of anthropomorphic forms speaks directly to the shamanistic and ceremonial dimensions of prehistoric art. Here are stories told. And they are stories in which we are unmistakably involved. They are not wholly intelligible (neither are the chants of the Mountain Spirits in the contemporary *yei bichai* of the Navajo), but they are deeply moving, and they emerge from the farthest reaches of our racial memory.

In these sacred images we come hard upon the confluences of instinct and thought, stasis and creativity, savagery and sensitivity, blindness and vision, the merest survival and the greatest triumph. To behold them is to see into the spiritual caverns of our evolution, and it is to see into eternity. We can ask no more, and we must not ask less, of art.

N. Scott Momaday
Tucson, 1996

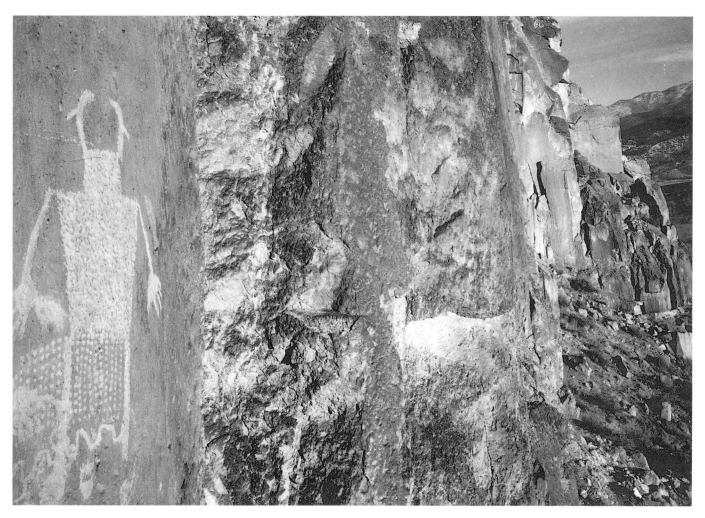

Horned Figure, Sevier style, Fremont Indian State Park, Tom Till.
Just smaller than life size, this horned anthropomorph probably represents a shaman,
the spiritual specialist and artist of his group

Preface

The conception of _Sacred Images: A Vision of Native American Rock Art_ derives from a Tom Till calendar photograph I spotted in the office of a local editor in the fall of 1993. The photo portrayed a shamanesque figure meticulously pecked into sandstone, high above Clear Creek, Utah. The solitary, shimmering figure seemed to levitate out of the stone and, in some essential way, to possess it—its presence defining the landscape, and the landscape articulating its presence.

Looking at this riveting image, I felt an overwhelming sense of possibility. I had, until then, seen rock-art photos in books used primarily as illustration. Scholarly publications, for instance, containing hundreds of black-and-white photographs, cataloged rock-art sites and deduced styles from comparative inventories of figures and shapes. Text and imagery in such books, though fascinating, tended to remove petroglyphs and pictographs from their contexts, abstracting and, thus, diminishing their impact. Till's photo showed it was possible to depict rock art in a way that illuminated its inherent beauty, power, and religious significance.

Over the ensuing months, I sought out and met with Tom Till, David Sucec, Craig Law, and John Telford, and this book's concept took shape. We envisioned creating a series of color

photographs that would portray the world of Utah rock art from the earliest prehistoric through the most recent historic styles. Using natural light techniques, the photographs would reveal these images as they stood on boulders, cliff faces, and overhangs. Singular photos would depict the aesthetic impact of each site. The aggregate would show the interaction of subjects both within and across styles. The total effect would be a constellation of representative images that uniquely conveyed the sensibilities, the experiences, and the concerns of Utah's prehistoric and historic peoples.

The interviews with contemporary Native Americans interspersed throughout the book were a fortuitous afterthought. We originally wanted the photos to speak for themselves. In fact, we felt this was imperative. Rock art scholars had partially obscured these images by surrounding them with layers of dense explication. We felt it was time to present *the subjects* of this growing body of speculation as they are found. Once interviews with Utah's and the region's Native American people got underway, however, all resistance to "interpretation" melted away. The interviewees introduced vantages on rock art that were not only compelling and novel, but that corroborated and deepened our understanding that this was, indeed, sacred communication.

Interview content fell into three broad categories: the mythological, the historical/traditional, and the ceremonial/experiential. The Northwest Shoshoni believe, for instance, that "rock writing" was created by "*Puhadibop*, . . . [supernatural] beings with spiritual powers"; the Hopi regarded the images as "historical docu-

ments" recording the migrations and the religious experiences of *Hisatsenom,* Hopi ancestors; and the Northern and White Mesa Ute and Southern and Northern Paiute acknowledged both perceptions, while emphasizing the ceremonial and experiential significance of the sites. Ultimately, these varied accounts converged. This confluence of viewpoints occurred because each type of account, each story, expressed and reinforced one aspect of the broader culture shared by all informants.

Selected from approximately two hundred images and thirty in-depth interviews, *Sacred Images: A Vision of Native American Rock Art* is, thus, a collaborative venture. Photos and excerpts reflect initial project goals and incorporate what we learned from informants along the way. Together, imagery and text dramatize an ancient vehicle of communication and the contemporary Native American response and relation to it. Although separated by centuries, the two modes intersect—interact. One vivifies and sustains the other.

The bulk of the book's photographs were taken by the three Utah photographers. Craig Law shot most of the Barrier Canyon and Ute-style pictographs and petroglyphs located in southern and northeastern Utah; Tom Till depicted Anasazi, or as the Hopi prefer, *Hisatsenom*-style "rock writing" found north of the Utah-Arizona border; and John Telford portrayed the Fremont-style petroglyphs situated in northeastern and central Utah. Philip Hyde, who intended to join us, was kept from participating in the project by a prior commitment. We used photos he took in the 1960s and 1970s to fill in gaps.

David Sucec, the project's art historian and rock art scholar-in-residence, identified major Utah panels and guided the photographers to many out-of-the-way sites. His understanding (carefully and generously shared) that aesthetics "is an access point into the sacred" underscored our deepest instincts and helped me prepare questions for the interviews. I wish to thank him and the photographers for their commitment to the work and their faith in the endeavor. I also wish to thank the Shoshone-Bannock, Northwest Shoshoni, Northern Ute, White Mesa Ute, Southern and Northern Paiute, and Hopi people who let me into their homes and trusted me with their words. Their stories translate the concepts of sacred images and sacred space into a shared legacy.

Leslie Kelen
Salt Lake City, October 1995

Note to the Reader

The title of this book, *Sacred Images: A Vision of Native American Rock Art,* reflects our awareness of this venture's parameters and intentions. Since imagery and text in this book *introduce* traditions whose scope extends far beyond the boundaries of this work, we make no claim to be comprehensive or exhaustive. On the other hand, we cannot shy away from the project's premise either: We believe in the sacred dimension of rock art and its import to contemporary life. Native America rock art has the ability to transcend sectarian boundaries and to convey an ancient encounter with the spirit that touches us all.

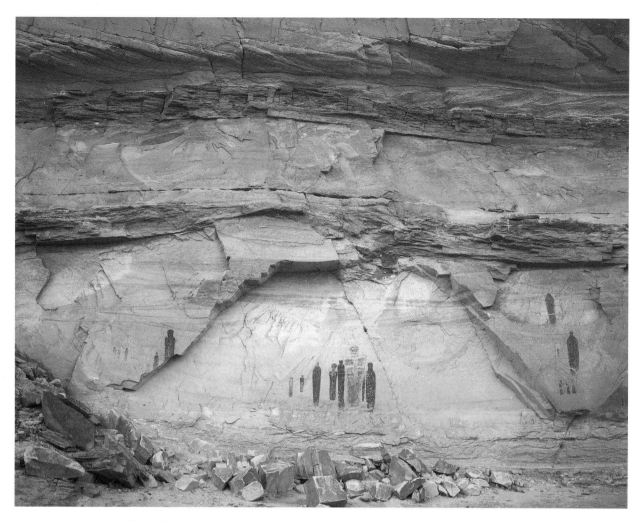

The Holy Ghost Panel, **Barrier Canyon style, Horseshoe Canyon, Craig Law.**
The aesthetic center of the Great Gallery is this extraordinary painting. The tallest anthropomorphic
figure, called the Holy Ghost, is about eight feet in height. These armless and legless figures are thought
to represent spirits.

A Configuration of Forces

The Art in Rock Art

Dropping down from Dead Man's Point into Horseshoe Canyon puts you within one long bend of the Great Gallery; a short walk down canyon, through the cottonwood trees, you get the first glimpse. Nothing can prepare you for the enormous scale of the site, and, even if you have seen the photographs or visited the site

before, the large figures invariably strike you as being more remarkable than you imagined or remembered.

On the smooth, south-facing canyon wall, three hundred feet long, are more than fifty painted figures and hundreds of drawn and pecked marks and images that constitute the Great Gallery. Centered in a recessed alcove,

the aesthetic focal point of this great wall of images is a large painted composition called the Holy Ghost Panel (plate 3).

Locals in this region commonly named natural features, rock-art sites, and images for some particular resemblance they saw to things in their own culture, such as The Maze, Temple Mountain, or the Great Gallery. Standing on

the narrow flat just below the full wall of painted images, you can see the resemblance to walls of paintings in the public spaces (art galleries and museums, even churches) that those early European-Americans saw a hundred years ago.

The Holy Ghost is not quite as easy a comparison. The figure does not look like the conventional European representation of the Holy Ghost or Holy Spirit. Being a pure spirit without form, the Holy Ghost was represented by symbols—rays of light and/or a dove. Utah's Holy Ghost was created more in the image of man. They were probably correct in attributing a supernatural status to this figure. However, at this time we cannot be certain who the artist intended the Holy Ghost figure to represent; neither is it likely that the early European Americans knew.

Those early visitors saw sacred images and an aesthetic presence at Utah's rock-art sites, and the images that provoked their imaginations continue to engage us today. Naturally, viewers have wondered about the identification of the individual images and the meanings behind the compositions and panels. These are, unfortunately, the types of questions that can rarely be answered to anyone's satisfaction.

Although there is a long tradition of archaeological research in the Southwest, the scholarly study (iconology) of the meanings of symbolic, traditional, or conventional images of prehistoric rock art is relatively young. American rock-art research lags several decades behind that of European and, as in Europe, consensus among scholars is rare. Even more recently than the scholarly study of Southwest rock art, a field of study that examines the prehistoric panels as visual art has emerged in the United States. The investigation of rock art as art can be advanced in two overlapping areas. The most available avenue is through analysis of the form, or what is visible and able to be seen by the eye. Visual distinctions can be found between forms. A complex or conglomeration of particular forms is designated as a style. Styles may suggest temporal and spatial relationships within and between culture groups. Less accessible, and more problematic, is the aesthetic approach, which seeks to discover the relationships, or configuration of forces, embodied within the totality of the pictorial materials, including, for example, attention to the creative process, the relationships of visual forms, the cultural and psychological meanings (iconography) ascribed to and emanating from images and their arrangements, and the style—the sequence of styles within a culture and a comparison with the styles of other cultures. Cross-cultural interpretation remains a difficult and sensitive area.

The Aesthetic Tradition

Many scholars feel that the Paleolithic cave paintings in Europe were the earliest, truly aesthetic, creations of man. There is no question that these impressive animal paintings constitute early indisputable evidence for the existence of the human creative spirit. However, the cave paintings are not the first evidence for the presence of the aesthetic impulse.[1]

Hominids began making stone objects—tools—more than two million years ago. But it appears that the concerns of the earliest stone-tool makers—the African Homo habilis—were only utilitarian. The earliest clear evidence of the aesthetic impulse is in the form of a large, symmetrical "hand ax" made by a European Homo erectus craftsman in the 150th millennium before Christ. What alerts us to the existence of the aesthetic impulse is seen in the form of the stone hand ax. It has a size and symmetry not required by its function. It seems much too large for everyday use[2] and has a symmetrical form that necessitated an additional investment of time and effort beyond what was needed to make an effective stone tool.

By 30,000 B.C., Old World Homo sapiens were making an impressive array of aesthetic images and objects. The earliest Paleolithic cave paintings have recently been dated to this time,

although most are thought to have been painted between ca. 15,000 B.C. and 8,000 B.C.

North America

Before 20,000 B.C., the first of three waves of Asian immigrants came to North America. According to art historian Terence Grieder,[3] each of the three waves brought with them whole cultural complexes, including established symbolic visual imagery, which, when in place, diffused slowly outward.

In the first-wave style, the imagery is predominately nonrepresentational, e.g., circles, patterns of dots, and parallel lines. First-wave symbols were organized around a metaphorical relationship between organic human processes and the process of the immediately surrounding nature, especially the reproductive processes. The color red was considered to be sacred for these hunter-gatherer bands.

Grieder thinks that the Cup and Groove style originates with the first wave because it is the only style that is found in all parts of the New World. The style consists of small depressions, pits, or cups pecked into bedrock or large boulders. Often they are accompanied by abraded grooves. These small, hollowed forms/circular images are thought to be symbolic and associated with female reproduction. There is no way to date these images, but on many of the boulders the images are completely repatinated (changed back to the original dark surface color of the boulder) and appear to be extremely old.

The second wave of immigrants, before 10,000 B.C., brought with them a symbolic complex centered on the tree, or pole, as a world axis (*axis mundi*) and a conception of the world as existing on three levels—this physical world (earth), the spirit worlds of the upperworld or the sky (abode of deities and spirits), and the underworld (land of dead). With this wave of hunter-gatherers came the shaman, a spiritual specialist and the artist of the band. The spirit of the shaman, through the ecstatic technique (trance), could travel up the World Tree to commune or mediate with the sky deities or down its roots to escort souls to the land of the dead or extract a lost soul from the underworld.

There is a use of feathers and bird symbols, representing the spirit or soul. The imagery is both representational and nonrepresentational, with depictions of ancestors and spirits. In Utah, the second wave is associated with Western Archaic culture(s). Belonging to the Western Archaic are the artists who painted the Barrier Canyon-style rock-art images, including the Holy Ghost Panel.

The third wave arrived before 1500 B.C. and brought with them a symbolic complex defined by celestial symbols. The phenomena of the sky during the day and night required the expansion of the vocabulary of symbols and, consequently, the reinterpretation of certain earlier symbols.

The circle, a symbol for the earth in the first wave, becomes the symbol for the sky in the third wave. The World Mountain, symbolized by earth and stone platforms, functions as *axis mundi* for third-wave cultures as did the World Tree and pole for the second wave. The third wave in Utah is best represented by the Pueblo agriculturists and their annual celestial ceremonial complex. Of course, the Pueblo people were not a pure third-wave culture; their cultural and ceremonial lives were layered with fragments, symbols, and psychological motifs from all three waves.[4]

Utah Rock Art

Utah has had human occupation for more than 12,000 years. And as with Europe, Utah's most impressive prehistoric art form is its rock art. The prehistoric Native Americans left many examples of their art throughout Utah at living and ceremonial sites and on the rock walls of their canyon and mountain homelands.

About 80 percent of all known North American rock-art sites are located west of the Rocky Mountains. Utah's own rock-art sites number in the thousands and include a large number of the finest panels to be found anywhere. Some sites may date to Utah's first inhabitants, but, at present, the earliest style to be dated (beginning ca. 6500–5500 B.C.) is the Barrier Canyon style. If this estimation is correct, it would be the oldest dated major painting style in North America. The

most recent, of course, is the Ute style with the creation of some traditional-styled panels extending into the early twentieth century.

There are at least ten distinct styles of rock art to be seen in the state of Utah, including the four major styles: the Barrier Canyon style (ca. 6500 B.C.–A.D. 500), the Hisatsenom (Anasazi) style (ca. 1000 B.C.–A.D. 1300), the Fremont style (ca. A.D. 500–A.D. 1350) and the Ute style (before A.D. 1600–A.D. 1930). These styles represent an art-making tradition in Utah with a time span of more than 8,000 years.

Barrier Canyon Style

Clustered within the river drainages of the Colorado Plateau, especially along the tributaries of the Colorado River, are found Utah's most spectacular and aesthetically significant rock-art sites. These prehistoric paintings were created by Western Archaic Native Americans, some perhaps as early as 8,000 years ago. Archaeological evidence indicates that these people were hunters and gatherers of food, moving on seasonal rounds within a fixed territory. They did not maintain permanent dwelling sites, but they did return to some seasonal shelters year after year for millennia. Large panels of their painted images are found on the walls of several major canyon travel routes (plates 2, 8, 15). Although we do not know the name that they called themselves, scholars have named their style of paint-

ing the Barrier Canyon style (B.C.S.).[5]

Like the European Stone Age cave painters, the Barrier Canyon painters were true artists, skillful in image making, designing and composing groups of figures. They possessed an unusually wide range of painting techniques and a command of the painting process. They painted freely using a variety of reds made from red ochre, or iron oxide (hematite). They frequently used white and occasionally green, yellow, blue, and black. Paint was applied with brushes, fingertips, hands, and fiber wads and by blowing paint from the mouth. The binder, or bonding agent (which keeps pigments/color particles from falling apart when they dry), is not known. B.C.S. artists also pecked, engraved, and scratched a small number of their images (plate 12).

Unlike other Utah Archaic rock-art styles,[6] there is a preponderance of anthropomorphic figures in the image inventory of the Barrier Canyon style. Painted B.C.S. figures can measure more than nine feet tall, and animal, bird, and insect figures have been drawn with consummate skill as small as one inch. Many of the anthropomorphic images, such as the Holy Ghost figure at the Great Gallery, are called spirit or ghost figures because they often lack arms and legs; and they sometimes have oversized, pupil-less eyes and antennae (plate 3). Because of their appearance and their very high position on the canyon walls, they appear to be hovering like spirits or ghosts (plates 3, 4, 6, 9).

Composite, or hybrid, figures (plates 11, 12, 13) and the spirit figures are often associated with vertical, snake, or zig-zag forms (plate 4), and frequently they are attended by birds, sheep, deer, unidentified quadrupeds, and hybrid creatures (plate 1, 9, 16). In two known cases, rabbits run up the spirit figure's arm, birds fly above the arm also moving toward the spirit figure and, in one case, rice grass grows out the tip of a figure's finger. At another site, birds circle plantlike antennae sprouting from the head of a figure. At yet another panel, a small hybrid figure with a human body, bird's feet, sheep's head, and snake's tongue holds an anthropomorphized bird in its outstretched hand while two lines of tiny desert bighorn sheep ascend towards him (plate 13). At these and other panels, the suggestion of intimacy between the spirit figures and the birds, animals, and plants is quite distinctive and is not found in any other rock-art style in Utah (plates 7, 10). The appearance of the spirit figures and the familiar associations mentioned above are considered evidence that a shamanistic tradition was alive among these Western Archaic people. There is also similar evidence of shamanism in the imagery of the Pecos River style, a Texas/Northern Mexican Archaic culture contemporaneous with the Barrier Canyon style. And indeed, the B.C.S. images do have a startling correspondence to shamanic imagery of late prehistoric/early historic Siberian tribes and northern Native Americans such as the Inuit.

Rock-art sites throughout Utah are frequently layered with images—style superimposed on style—marking thousands of years in time and providing clear evidence of the temporal sequence of rock-art styles. Invariably, Barrier Canyon-style images are superimposed by Basketmaker-, Pueblo/Fremont-, and Ute-style images, in that order. It is very possible that, at some sites, as much as 4,000 years could have elapsed between art-making episodes (plate 20).

Hisatsenom Style

Ancestors to the Pueblo cultures, the Basketmakers are the earliest (ca. 1000 B.C.– A.D. 700) discernible phase of the Hisatsenom (Anasazi).[7] The Basketmakers were named for their beautiful and skillfully constructed baskets that were first discovered in the dry caves in the San Juan River area.

Basketmaker bands lived like other Archaic cultures—hunting and gathering food and traveling in seasonal rounds. It is thought they cultivated patches of wild food to maximize their yield. This "tinkering" probably led them into a lifeway committed to agriculture and a more sedentary lifestyle. Their more settled life permitted an unparalleled development, during the Pueblo phases, of architecture, weaving, ceramics, and interior wall painting.

Along, and near, the San Juan River and its side canyons, Basketmaker-style anthropomorphic figures show a marked similarity to Barrier Canyon- and Uinta Fremont-style figures (plates 4, 25, 36, 38). They are similar in size, body form, and interior design. There are, however, important differences. San Juan Basketmaker figures are always represented with arms and legs. Frequently the hands and feet are naturalistic, painted or pecked in splayed (viewed from above) positions (plate 23, 25). The body forms appear stylistically flat and rectangular. Certain details associated with the later Pueblo phases, such as ear bobs, ceremonial headdresses, and body attire, are already evident in these early paintings and peckings.

Along the San Juan River, the Basketmaker panels are almost exclusively pecked. The largest figures are life size, and most of the panels face south toward the sun (plate 25). Away from the San Juan, particularly in the Canyonlands area, the figures are most often painted and just smaller than life size (plates 21, 22). Basketmaker images, painted or pecked, tend to be more subdued, more workmanlike, than those created by the virtuoso Barrier Canyon artists.

However, many scholars feel that these early Hisatsenom rock-art images and panels display characteristics similar to the shamanistic B.C.S. images. This, and other cultural material, suggests that they shared a common hunting-and-gathering lifestyle if, in fact, they were not the same people.

During the latter part of the Basketmaker cultural phase, the Hisatsenom began to develop rudimentary architecture (pit houses) that would later develop into the grand living sites such as Mesa Verde and Chaco Canyon.

As the new art forms of ceramics, weaving, architecture, and kiva painting developed, the number and quality of the outdoor rock-art panels diminished. The new lifestyle was reflected in the rock-art panels by less-ambitious compositions, less-skillful technique, and smaller, less-imposing anthropomorphic figures often with a different arrangement of arms and legs and without the detailed hands and feet (plate 30). There was an increase in the number of animal and bird representations (plate 29).

Two new types of anthropomorphic figures appear in the Canyonlands area during the late Pueblo period (ca. A.D. 1050–1300). Both are painting styles and both appear to have some Fremont-style influences. The first is called the Faces Motif. The images are without arms and legs, just smaller than life size, with Fremont- and Basketmaker-like interior body designs. The paint application technique and torso form also recall the Barrier Canyon style (plate 33, 34). The other Pueblo II–III anthropomorph is a shield figure (plate 35) also quite similar to the Fremont shield figures found in the Uinta Basin. Handprints, positive and negative, consistently occur throughout both Hisatsenom cultural phases (plate 31).

Hisatsenom occupation of southern Utah ceased around A.D. 1300 with the culmination of a gradual but wholesale migration to more southern and eastern locations, where some of their descendants still live in pueblo style.[8]

Fremont Style

From about A.D. 700 to 1300, while the Pueblo people occupied the bottom one-quarter of Utah, a culture that archaeologists call the Fremont occupied the top three-quarters of the state, spreading across the state lines in the east, west, and north. Except for the northeast corner of Utah, the Fremont seem to have left Utah about the same time as the Hisatsenom.

It is not clear who were the people archaeologists call the Fremont, nor is it possible to determine who are their descendants. The Hopi believe that the Fremont were Hisatsenom and maintain that some Fremont became the Snake, Squash, and Greasewood clans of the Hopi nation in northern Arizona. Although archaeologists shared the Hopi belief earlier in the century, they now believe that the Fremont were a different culture from the Hisatsenom. Archaeological evidence suggests that the Fremont were not as committed to agriculture as were the Puebloans, and when the conditions were not favorable for farming, they reverted to the archaic lifeway of hunting and food gathering. The Fremont continued to live in pit houses when the Pueblo people were constructing their dwellings above ground. However, Fremont rock art remained vigorous well after the Pueblo culture had turned more of their attention to the domestic arts.

Nevertheless, the rock-art styles of the Fremont are clearly distinct from the Hisatsenom styles. The earliest (ca. A.D. 500) and most northern Fremont variant (Uinta) rock-art panels are dominated by large, pecked, anthropomorphic figures (plates 36, 37, 38) with elaborate necklaces. The large Uinta figures are similar to B.C.S. and Basketmaker figures in the southern part of the state. At some sites, the elaborate necklace images were pecked as singular images without figures. Shield figures (plate 35) and shield forms are common in Uinta panels—usually created by a combination of pecking and painting techniques.

In central and southern Utah, there are two variants of Fremont style—the San Rafael and the Sevier. The two regional variations are quite similar in their image inventory, but there is a difference in the forms of the horned anthropomorphic figures (plates 44, 49). The horned figure is currently interpreted as an individual with power, perhaps a shaman. Panels in both styles include images of individuals of power, although smaller and less frequent in number than those in the Uinta style. The anthropomorphic figures assume trapezoidal body forms with upcurved horns or feathered headdresses. Quadrupeds, especially sheep images, snakes, and nonrepresentational imagery dominate the image inventory at these central Utah Fremont rock-art panels (plates 42, 47). Hunting scenes are common (plate 45). Occasionally, armless and legless red-painted and pecked anthropomorphic figures are found grouped together (plate 47). It appears that these two-dimensional images correspond exactly with the distinctive Fremont figurines, which have also been found in sets.

In areas of prolonged interface with the Hisatsenom, Fremont ceramics have clearly been influenced by Puebloan imagery. Conversely, it appears that the Hisatsenom rock art was influenced by Fremont imagery.

Ute Style

Ute rock art is found as far south as the San Juan River, west to the Wasatch Front along I-15, north into the Uinta Mountains near the Wyoming border and extending into the Colorado Rockies as far east as Denver. The Ute style predates the invasion of the Spaniards in the 1500s.

Utes believe that they are related to the Hopi. Linguists confirm that the Utes share the same language base as the Hopi, Paiute, Shoshone, and the Aztecs of Mexico. The Ute rock-art style is quite distinct from Pueblo styles, in technique and in types of imagery. After ca. 1600 and the arrival of the horse, plains-type imagery (horses, bison, teepees) appears in

Ute rock-art panels (plates 52, 57).

The Early Historic Ute style, perhaps before horses, contains shield stick figures; stylized, somewhat abstract figures; and a distinctive bison image represented with its head down (plate 51). Over time, there is an increase of realism and naturalism in the representation of horses, animals, and birds (plate 54). Images of individually patterned shields—most often painted in red and white (plate 56)—and Plains Indian war bonnets and lances also appear in the Ute image inventory at this time.

After the mid-1800s and associated with the Reservation Period, European imagery, including wagons, trains, rifles, and European American houses, began to appear in Ute rock-art panels (plates 58, 59). The earlier imagery (horses, animals, birds) also continued to be pecked and occasionally painted. While the painting technique is often unskilled, the pecking techniques are more consistent in quality with earlier examples.

Ute rock-art panels in proximity to reservation land are most often a jumble of superimposed images. The oldest images, underneath, are often Barrier Canyon, Fremont, or very early Ute style. The images scratched and pecked on top are often only a few decades old. At these sites, the tradition of making images on rock walls has continued from distant prehistory through early history to the present day. Like flotsam deposited on the shore after high water, these layered images mark the cultural currents that have swept over Utah's aboriginal people.

The Future of Utah's Rock Art

Utah is blessed with many world-class prehistoric rock-art sites. Our panels are a significant part of the cultural heritage of Utah and North America. Yet they are virtually unprotected.

Many sites have been seriously compromised by vandalism and much of their information destroyed. Other panels, especially those easily accessible, are in danger of further degradation. Some are suffering from the effects of aging and weathering. At this rate of deterioration, many of us fear that our grandchildren will never have the opportunity to appreciate and wonder at many of these marvelous works of art.

Faced with inadequate budgeting, some government agencies are now keeping the locations of Utah's rock-art sites secret. The irony of this policy (saving the sites for us by not telling us where they are) seems to be lost on our public land managers and administrators. We must recognize that our prehistoric art is a national treasure (as are our national parks) worth the investment necessary for adequate protection and management.

Recently, two major rock-art sites have been conserved, have had their graffiti removed, partially returning the panels to their original condition (plates 16, 18). With public (government and private) support, more of these priceless panels could be restored and, if protected, maintained for future generations to study, appreciate, and enjoy.

David Sucec, Curator, Sacred Images

FOOTNOTES

1. *Aesthetic impulse:* A visual "eloquence" universally manifested in the elegance or appropriateness of form. Often a seamless melding of content with form.

2. An examination of its edges revealed very little wear, suggesting ceremonial association.

3. Grieder, Terence. *Origins of Pre-Columbian Art.* Austin: University of Texas, 1982.

4. The Hopi are reported to perform a ceremonial chant whose words are so ancient that most of them are unintelligible to chanters.

5. Styles in rock art are often named after the locations in which they are first identified. Although the type site for Barrier Canyon style is the Great Gallery, located in Horseshoe Canyon, when Polly Schaafsma identified the style in 1970, the locals called it the Barrier Canyon. Hence, the Barrier Canyon style.

6. Great Basin Abstract style, Glen Canyon Linear style, Chihuahua Polychrome style.

7. The Hopi prefer to use *Hisatsenom,* their term for their ancestors, rather than the Navajo term *Anasazi,* which translates to "ancient enemy ancestors."

8. The oldest continuously occupied town in the USA is the Hopi village of Oraibi on the Second Mesa in northern Arizona, established ca. A.D. 1200.

(ca 6000 B.C.–ca. A.D. 500)

Barrier Canyon Style

I can't speak for everybody. But I was taught that when you go to these sites for your medicine, you thank the Grandfathers, the Creator, for that power there, and ask them for some help along the way, on your trail, and thank them if they give you something, and thank them if they don't give you something. There are different kinds. A lot of them will tell you a story. But the spiritual kind you can draw power from. The only way to explain this power is that you feel it rather than see it. You can see the images on the rock. But that's not what you are looking at. You are looking with a different eye, not the ones in your face.

There are certain spots on this earth where you can get that. I guess, over the last few thousand years we've found those spots that have a little more going for them. And those are the ones we've picked to fast at.

DARRELL A. GARDNER SR.
NORTHERN UTE

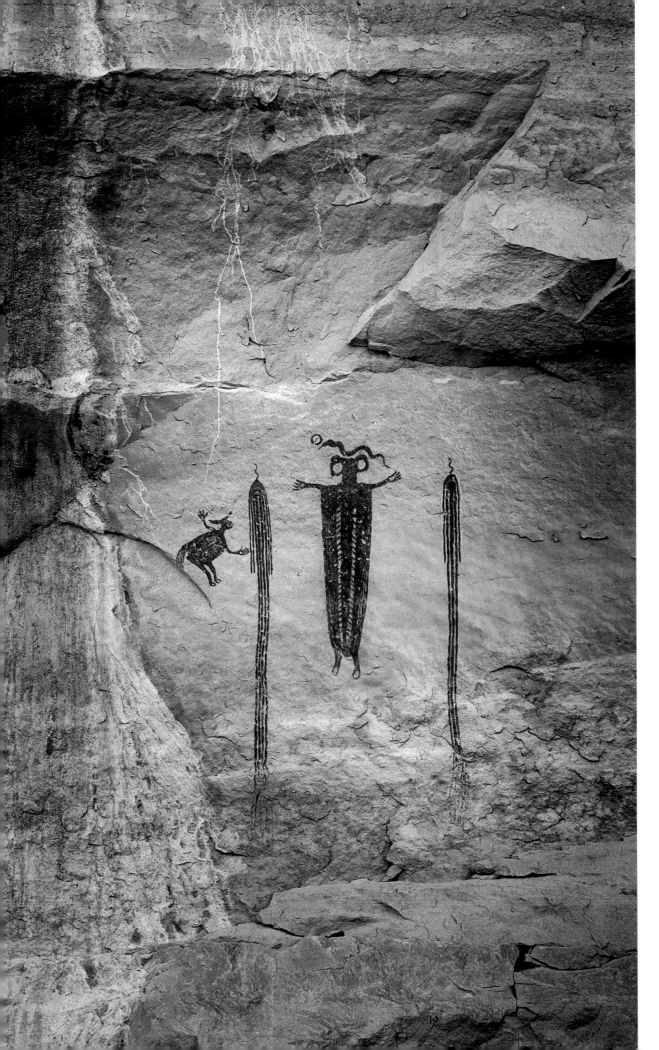

Plate 1

Skeleton Shaman, Barrier Canyon style, San Rafael Swell, Craig Law,

This composition (vertibrae/rib motif, animal association) is considered to be strong evidence that the Archaic artist/culture was a part of the ancient tradition of shamanism. Less than life size.

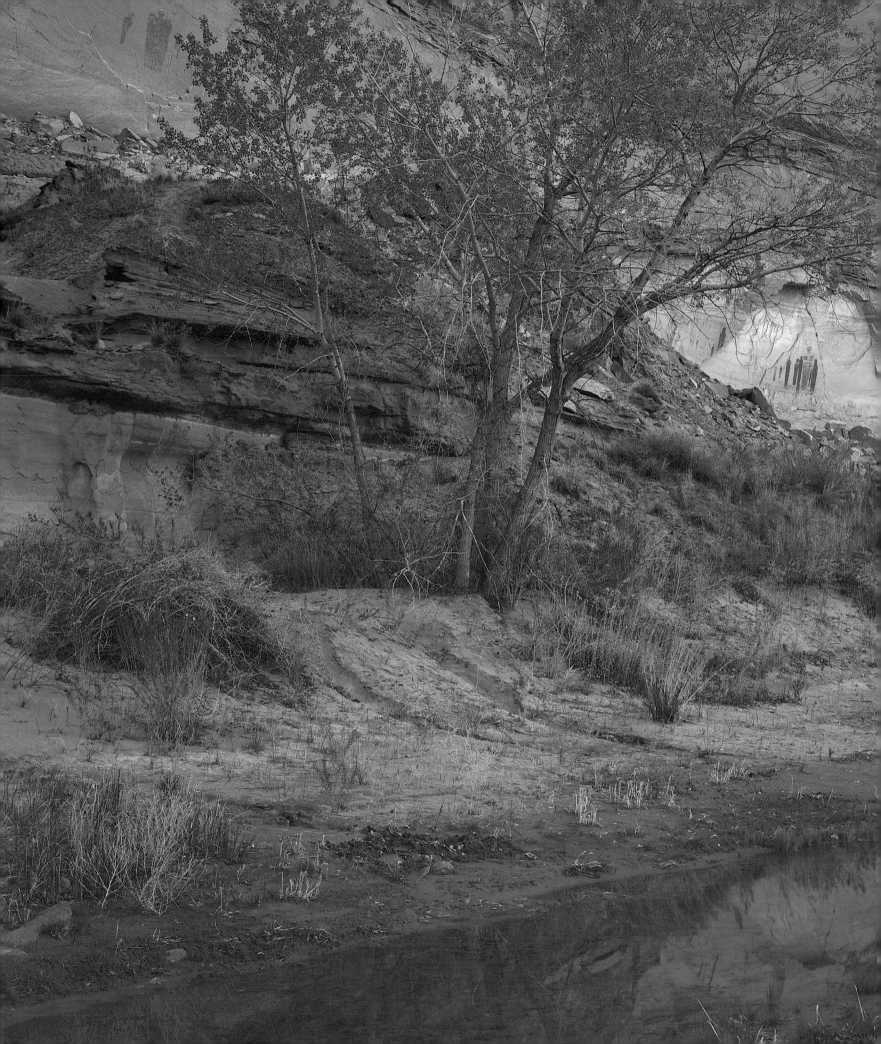

Plate 2

The Great Gallery, Barrier Canyon style, Horseshoe Canyon (Canyonlands National Park), Craig Law.

Sections of the Great Gallery can be seen through the cottonwoods. This three-hundred-foot-long outdoor art gallery is the type site for the Barrier Canyon style.

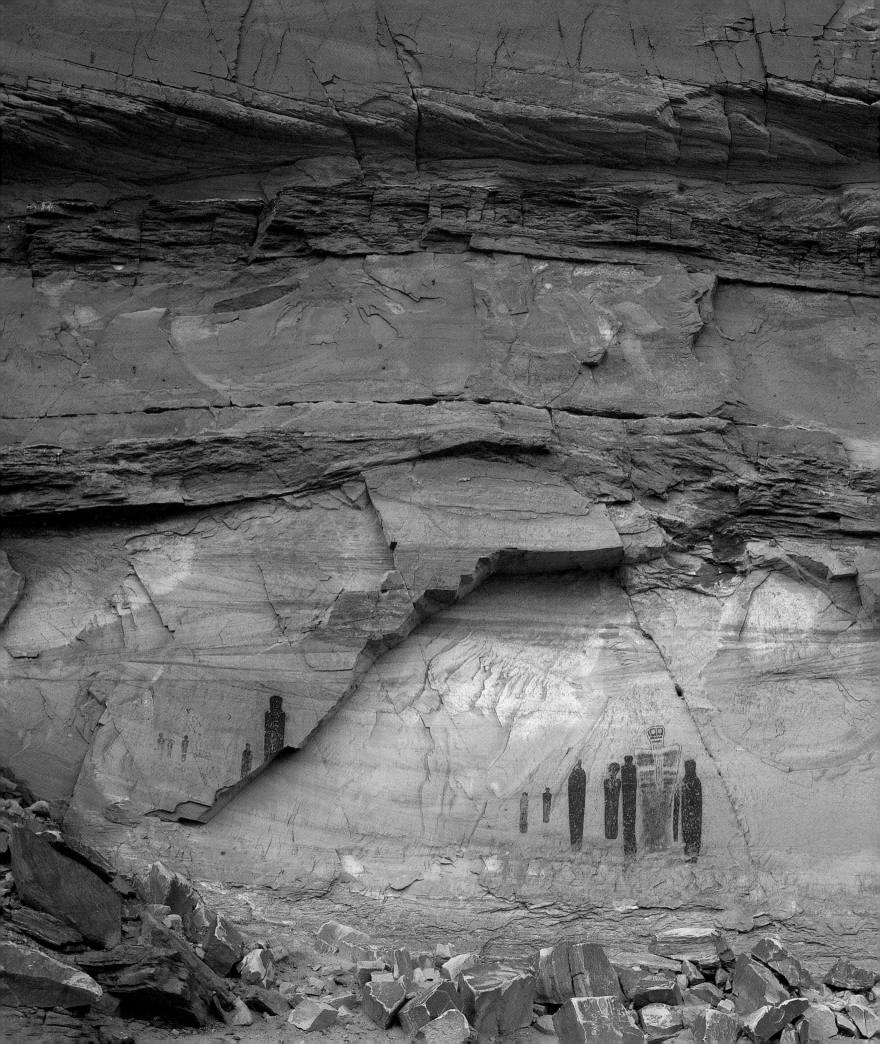

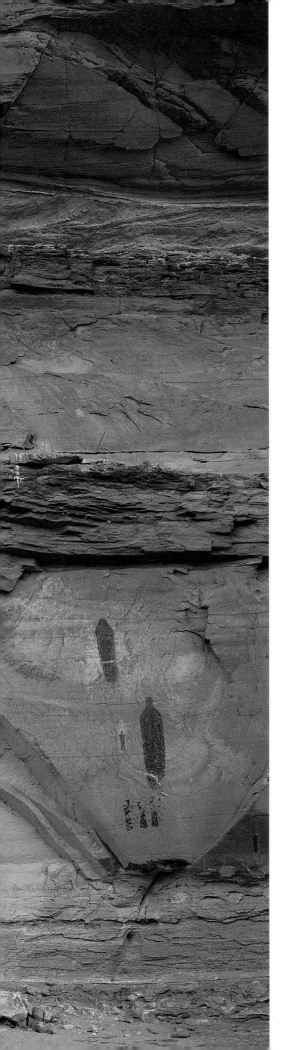

Plate 3

The Holy Ghost Panel, **Barrier Canyon style, Horseshoe Canyon, Craig Law.**
The aesthetic center of the Great Gallery is this extraordinary painting. The tallest
anthropomorphic figure, called the Holy Ghost, is about eight feet in height. These armless
and legless figures are thought to represent spirits.

My grandfather's name was *Dabootzi,* which means cotton-tail rabbit. And he was the best storyteller. He was really amazing. And it was through him we learned about rockwriting. You know, Indians did not tell stories during the summer. We felt something dreadful was going to happen if we gave information [in the summer], so we did not give things out then. During the winter, grandpa would come to our house and sit us around him. He'd sit in the middle, and he'd tell us stories and stories and stories. And we had to stay awake. Every once in awhile he'd call one of our names and ask, "Are you awake?" If you answered, "Yeah," he'd go on with his story. If somebody didn't answer, grandpa just went out the door. The next night, he would come back and start again.

He told us about this thing called *Puhadibop. Puha* means a spiritual type of power; *dibop* means writer, somebody that wrote *Puhadibop.* He told us these writings are not done by humans. They are not done by Indians. They are done by beings with spiritual powers and they tell us stories of all kinds—stories of their travels, their beliefs. But [he cautioned]: don't let anyone tell you they are done by humans because they are not. They are done by somebody greater than a human. "Look at some of these writings," he said. "They are [placed] high up in the mountains where no man can reach. Only these spiritual beings can go that high."

MAE PERRY
NORTHWEST SHOSHONI

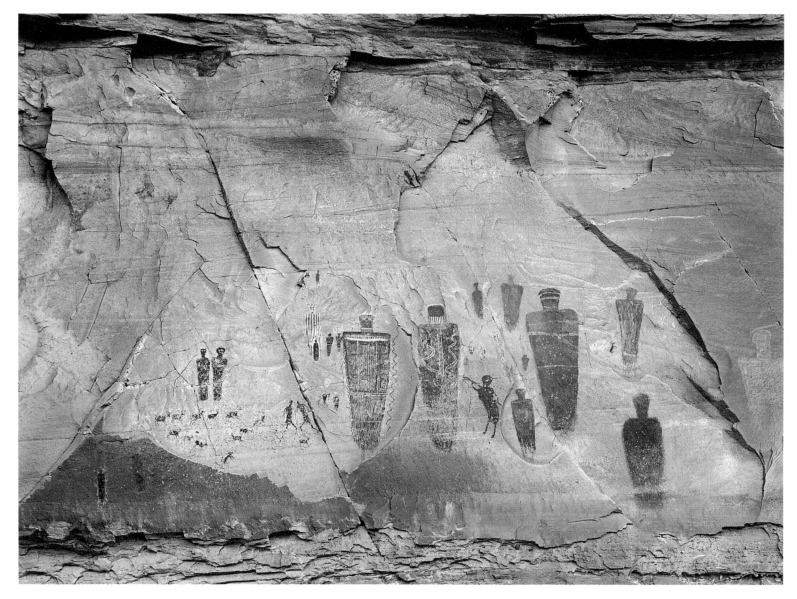

Plate 4

The Great Gallery, Barrier Canyon style, Horseshoe Canyon, Craig Law.
The large anthropomorphs are called spirit figures. They are often without arms
and legs and have an otherworldly quality. The smaller anthropomorphs, with appendages and engaged
in some activity are called citizen figures.

Between the time I was fourteen and sixteen, I rode for a ranging company out on the Ute reservation called Nutter's Ranch. I had already seen most of the pictographs around my home. But when I did this, we rode into small canyons and gulches to look for cattle, and I came across more of them. I was intrigued because some of the images seemed to be an accounting of animals, like the winter counts of the Plains Indians, and it was, I thought, very beautiful. That was my first recognition that these figures had a spiritual nature. I can't explain that exactly, except I felt they had real significance to my people.

Later in life, I saw pictographs and petroglyphs over near Canyonlands, and they were very different and very impressive. I saw them first in the 1950s, when Bates Wilson, a Park Ranger there, who knew of my reverence for them, took me to see many of these figures. What shook me about them is that you could tell they were the typical Indian build—squared shoulders, box-like trunks. Which to me said that these were probably feast and famine people. They tended to store a lot of energy and food in their trunks, rather than on their legs. So I thought they left me a message in that respect.

But what struck me was that there was an eerie feeling about many of these figures. They were very tall and ghostly, which was impressive and scary. The Canyonlands figures also had decorations on their bodies—garlands, necklaces, bracelets—so that was very special. I recall that Mr. Wilson felt they were monumental figures within the tribe. I had a different feeling. I felt they represented spirits or forces within the community that had been responsible for the pictures being there in the first place. In other words, I felt they were supernatural.

REVEREND QUENTIN KOLB
NORTHERN UTE

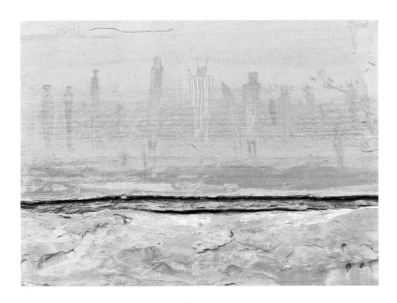

Plate 5

The Harvest Panel, Barrier Canyon style, The Maze (Canyonlands National Park), Philip Hyde.
A major Barrier Canyon-style rock-art site. Here, some spirit figures have legs and sometimes stylistic representations of arms. In a few instances, the legs appear to have been added at a later date. The figures are larger than life size and some are extremely stylized.

Plate 6

Ancestor Panel, Barrier Canyon style, Western Canyonlands area, Craig Law.

Although the images on the right side are so faint that they are difficult to see, this unmarked Barrier Canyon style rock-art site is in pristine condition. Hopi informants believe that these Archaic figures may represent ancestor (Hisatsenom) spirits.

Plate 7

Crowned Figure With Familiar, Barrier Canyon style, Hanksville area, Craig Law.

The white forms on the head may represent a crown of feathers. This life-sized figure is similar in form and iconographical detail to one of the images at the Great Gallery, about 60 miles north.

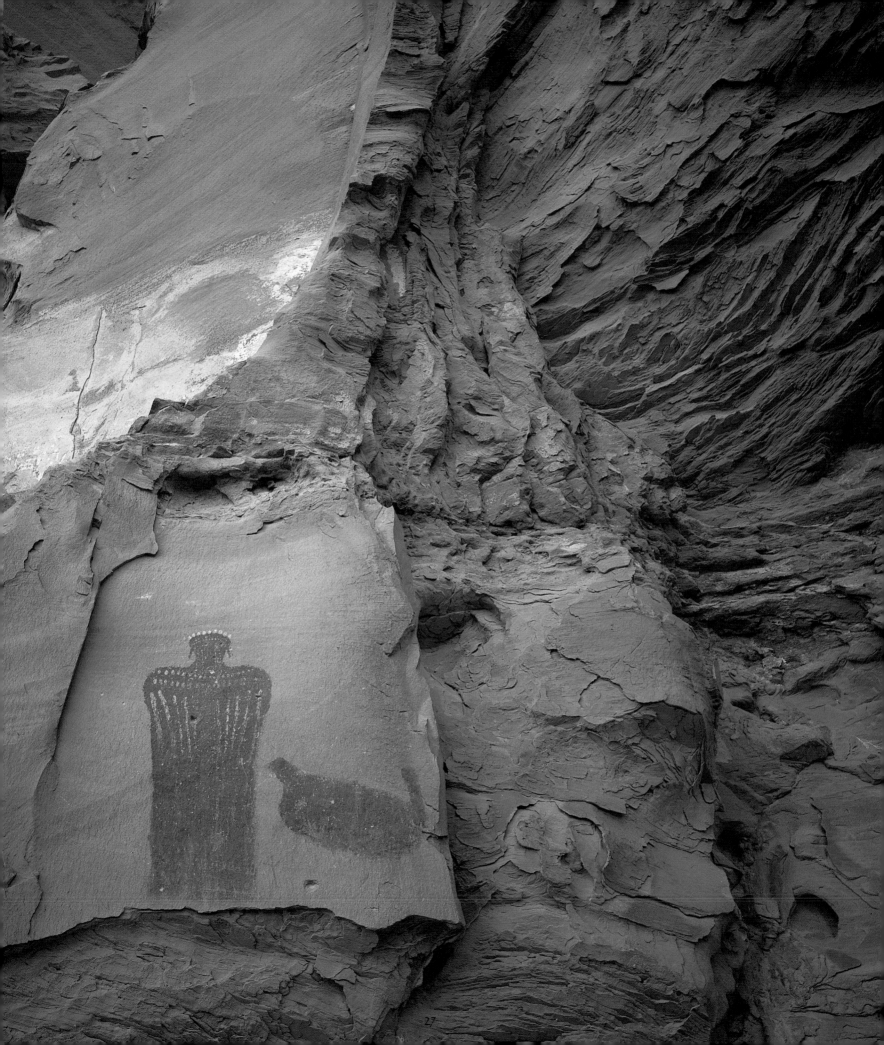

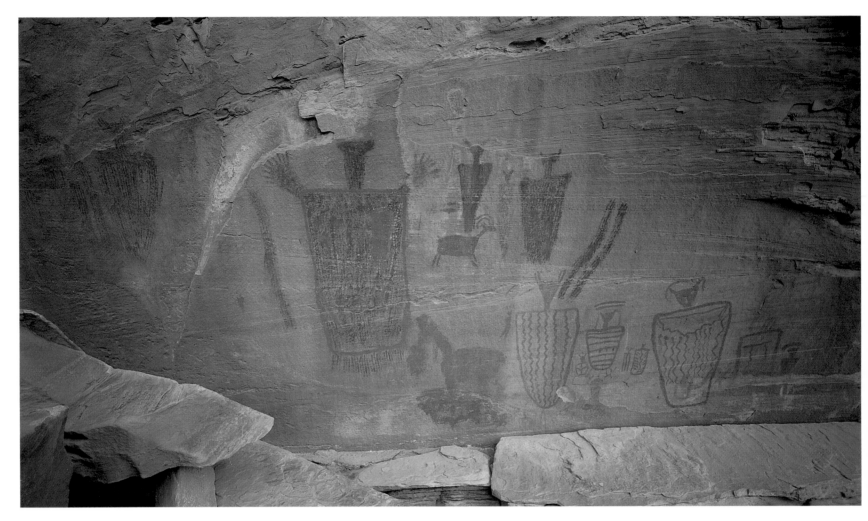

Plate 8

Slanted Wall Panel, Barrier Canyon style, Eastern Canyonlands area, Craig Law.

There appears to be three or four types of spirit figures in this panel, most likely representing a number of
time periods. The largest figure is about life size.

Long ago, the *Mokweetch** lived high along the cliff sides. My grandfather told me, there was a large eagle that would prey upon them. Therefore, to shelter themselves from these birds, they made their houses in the cliffs. The land looked the same as now, and the *Mokweetch* gathered plants and carried them in big baskets made of deer hide. They gathered the fruit of the yucca, chokecherries, wild onions, pinenuts, and all the other berries around. All this they would eat. They gathered these plants along the tops of the mountains and in the canyons where they grew in large quantities. They placed the food in their baskets and stored it there.

They also used the deer. They dried its meat, stored it, and made clothing from its hide. They would stretch the hide on top of a rock and remove the animal's hair. To cure the hide, they used the brain of the animal, rubbed it on. This made the hide smooth, then they smoked it. During the winter, they wore thicker skins or several layers of buckskin with the hair left on. When it was hot during the summer, they just wore a breech cloth.

Their shoes were also made of hides and the fiber of the yucca and the cedar. Using needles of oak or bone, they sewed the leather onto the fiber. They gathered water in clay containers. They had large containers to hold the water they needed to sustain them.

But the people lived in constant fear.

They were constantly on the move, looking out for these large birds, much larger than today's eagles, that bothered them. They feared these birds because they swooped down and took the people and fed them to their babies. So they never had permanent homes. Unlike the white man, they always moved from place to place. And this is the people the Utes came from. They came from these people, my grandfather said.

Lola Mike
White Mesa Ute
Translated from the Ute by
Aldean Ketchum

Mokweetch is the Ute name for the ancient Hopi.

Plate 9

Courthouse Wash Panel, Barrier Canyon style, Moab area, Craig Law.

The very elongated type of spirit figure that dominates this site is commonly seen throughout eastern Utah and western Colorado. Tallest figures are more than life size.

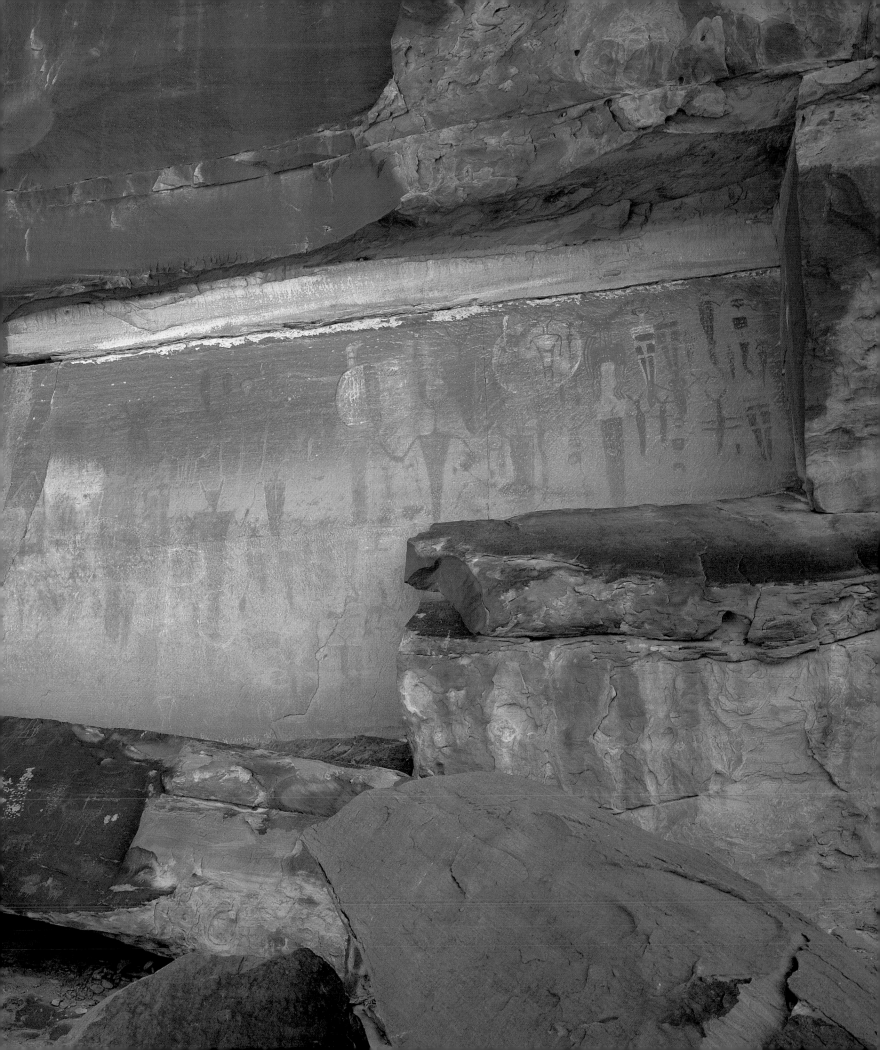

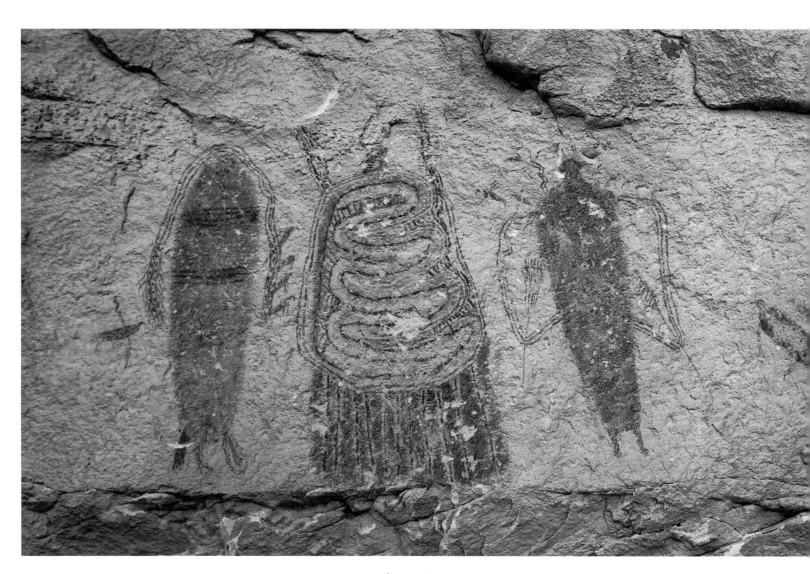

Plate 10

***Junction Panel,* Barrier Canyon style, Moab area, Craig Law.**

The intimate association of birds, animals, and plants with the anthropomorphic figure and other large painted forms, seen here, is a distinctive feature of the Barrier Canyon style. The tallest images are about four feet in height.

When my grandfather was a youth, they would take an Indian boy to where these rock writings are and leave the child out there for three days and three nights, all alone. They called it Seeking a Dream. He was supposed to stay there until he had a dream of what he would become. He might have a great dream about an eagle, then this *Puha* would tell him, "You are going to be as powerful as an eagle, and you will become a great leader and everyone will look up to you."

His people went up on the third day and asked him, "Are you ready to come home?" He said, "Yes, I've had a dream. My emblem is going to be an eagle." So when he came down, he tried his best to live up to this dream, and anything he had—if it was a jacket or a tepee—he had an eagle painted on it and everyone knew that's what he believes. That's his emblem. Or else he may dream that he saw a buffalo, and he would be as strong as a buffalo; or he may have dreamt of something humbler like a hummingbird or a coyote. Our people believed the coyote is a storyteller. He can go from one place to another and tell stories or tell what's going to happen to you. They believed if that coyote was his dream, he will sense when somebody is going to die. The coyote will go to somebody's tepee, or somebody's home, make so many barks, or howl, and he will know somebody in that family is going to die. Somebody may have this knowledge.

Mae Perry
Northwest Shoshoni

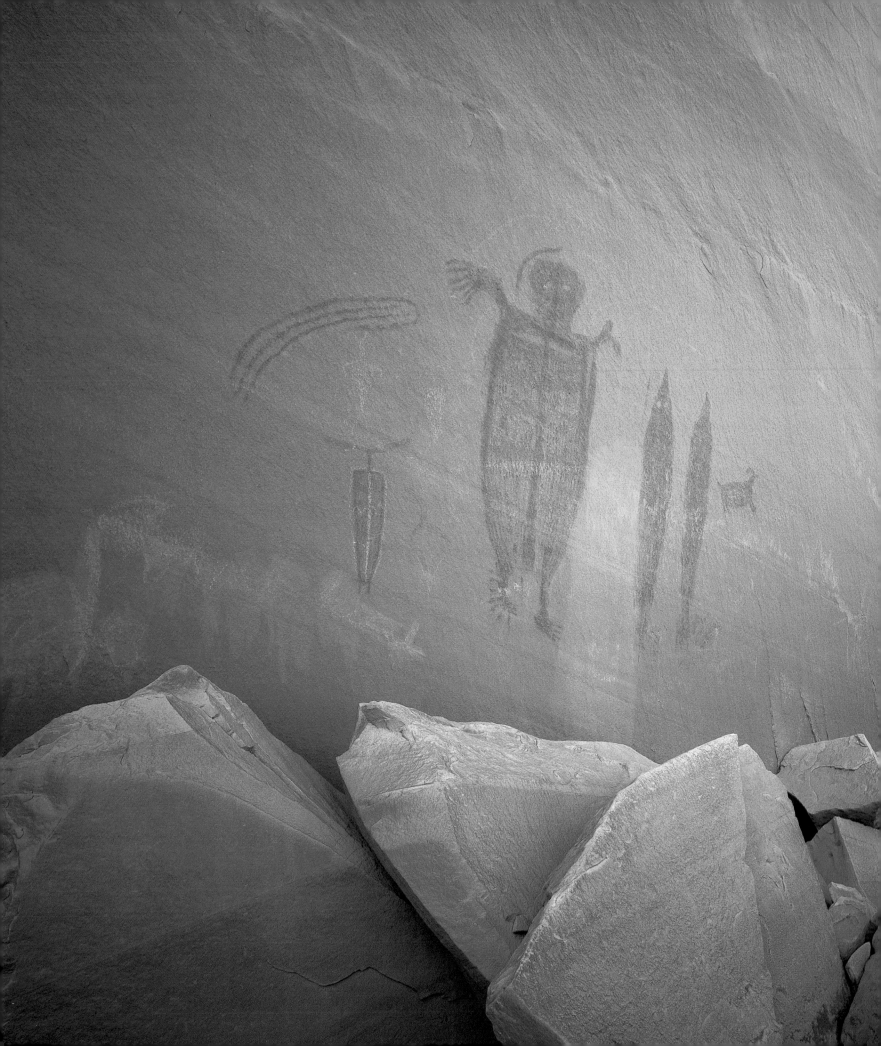

Plate 11

Confluence Alcove, Barrier Canyon style, Colorado/Green Rivers confluence area, Craig Law.

This photograph shows one of several panels located within an immense south-facing alcove. At many Barrier Canyon-style rock-art sites, the images are placed at an elevation that allows viewers easy visual access, sometimes at great distances.

There was once a people called the *Weenuche*—the old, old Utes who came from the flood. *Wee* means a flood, *Nuche* means people. The story told is that the people were in baskets. The baskets sat on a large body of water, and when they hit dry land, the other people started moving out, yet the *Nuche* stayed. When the waters rose again, these people were swept away. But the *Weenuche* in the baskets survived.

At one time, the *Weenuche* had a lot of medicine men. Each medicine man had his own skills, much like doctors nowadays who have special skills for [treating] certain illnesses. They go to school for many years, become specialists. The *Nuche* had these people. They were called *Puhagat,* medicine man. They learned at a young age. They were apprenticed to other medicine men and they learned the skills. But these people got jealous of one another. They started using their medicine against one another. When they decided to use good for bad, it destroyed a lot of people. And the reason the *Weenuche* left this area is because they lost respect for one another.

So somewhere along the line there is that big gap—that break with the earlier inhabitants—which a lot of people can't figure out. But I think the evidence is walking around them. They can't see it, but the *Nuche* are still here. The Hopis are still here. The pueblo people are still here. So it's their [the *Weenuche's*] descendants who live in this area. And a lot of this rock art deals with their clans. The clans used the animals—the snake, the deer, the bear—that each family identified with. So everywhere they went they wrote something down on the wall. They believed the spirits of the animals were there to guide them—much like in our Bear Dance*—so they wrote down what they believed.

ALDEAN "LIGHTNING HAWK" KETCHUM
WHITE MESA UTE

*Considered one of the most ancient and important of Ute ceremonies, the Bear Dance was brought to the people by a young hunter who met a bear coming out of hibernation. According to tradition, the bear taught the warrior the dance and the songs that would help his people stay together as a tribe.

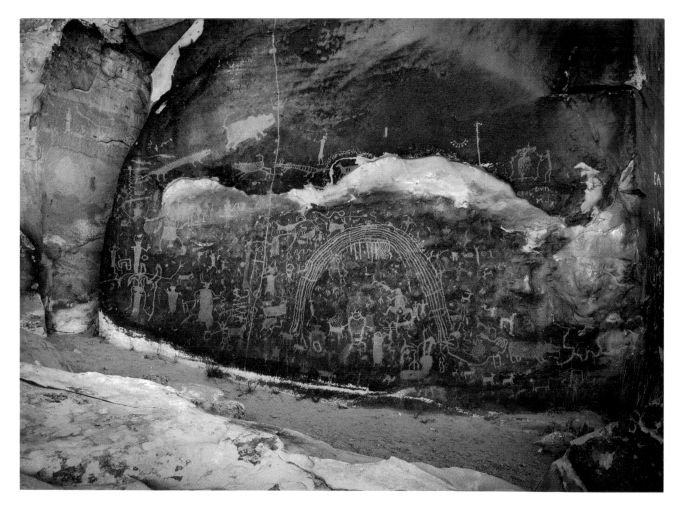

Plate 12

Rochester Rock, Barrier Canyon style, Castle Valley, Emery County, Craig Law.

This rock-art site is located at the junction of two canyons. Teeming with lively images, it is the
largest pecked panel in the Barrier Canyon style. Although vandals have removed and destroyed part of the
panel (upper right center) it is in remarkably good condition.

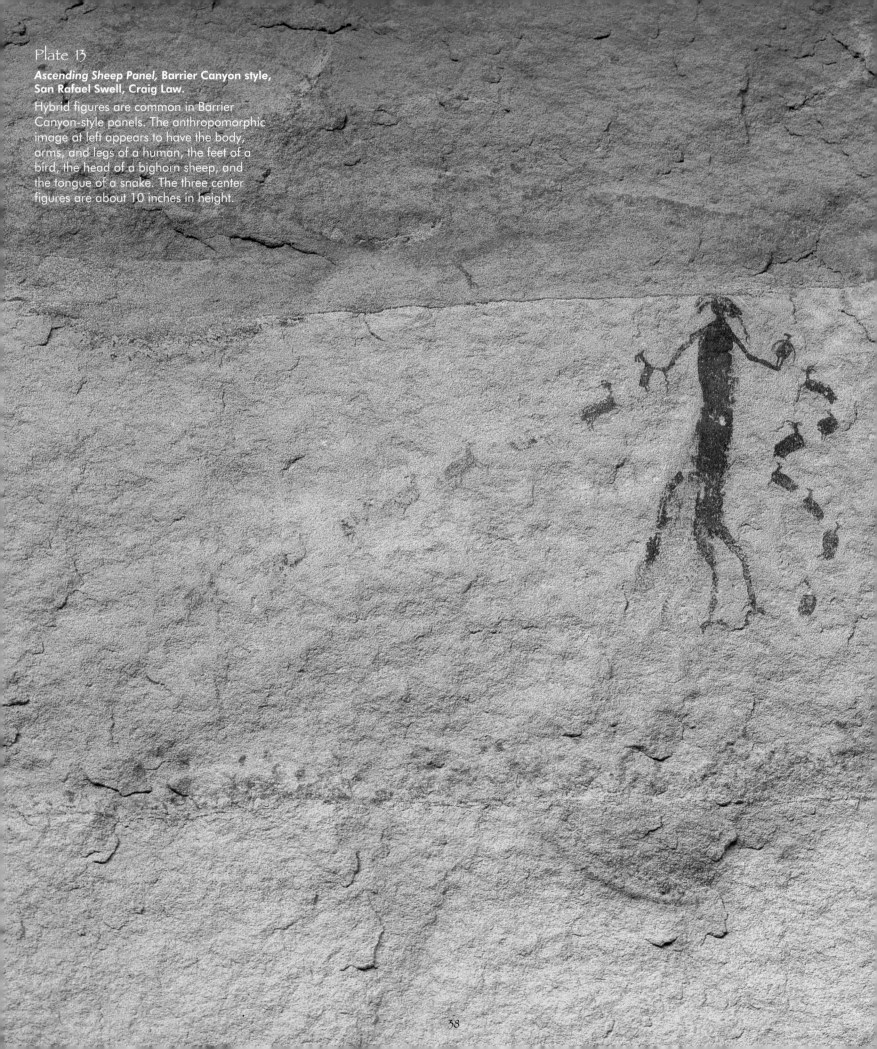

Plate 13

Ascending Sheep Panel, Barrier Canyon style, San Rafael Swell, Craig Law.

Hybrid figures are common in Barrier Canyon-style panels. The anthropomorphic image at left appears to have the body, arms, and legs of a human, the feet of a bird, the head of a bighorn sheep, and the tongue of a snake. The three center figures are about 10 inches in height.

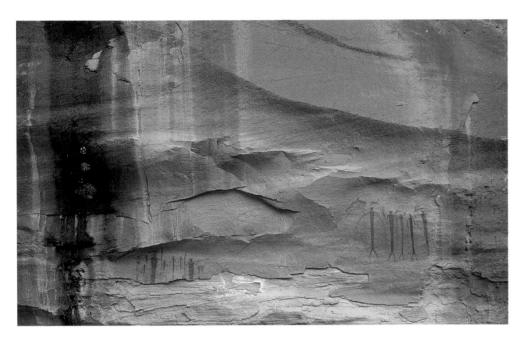

Plate 14

**Virgin Springs Panels, Barrier Canyon style,
San Rafael Swell, Craig Law.**

The two small panels in this photograph may be about
hunting and gathering. Representations of rabbits, deer,
avian creatures, plants, and rain are featured in the
right-hand panel. While plants, baskets, and spears are
prominent in the left-hand panel. Tallest images are
about four feet in height.

Long ago, my grandfather said, the
people would weave ropes from
rawhide, and hang from these ropes to
create the art rocks on the sides of the
cliffs. The people doing this were young
men being taught by the medicine men.
Writing on the rocks was a way to teach
these young men about the life they were
living, as well as an art form, much like the
artists or writers of the modern day. In
this way, they showed the young men
about the animals that lived in a certain
area, like big horned sheep, snakes,
lizards. So the young artists told stories
under the guidance of the medicine men.
The medicine men also taught apprentice
warriors and medicine men about certain
animals and ceremonies. Some places
contain the instructions they were given.
They wrote it down so they would know it
and not forget what they were told.

Lola Mike

White Mesa Ute

Translated from the Ute

by Aldean Ketchum

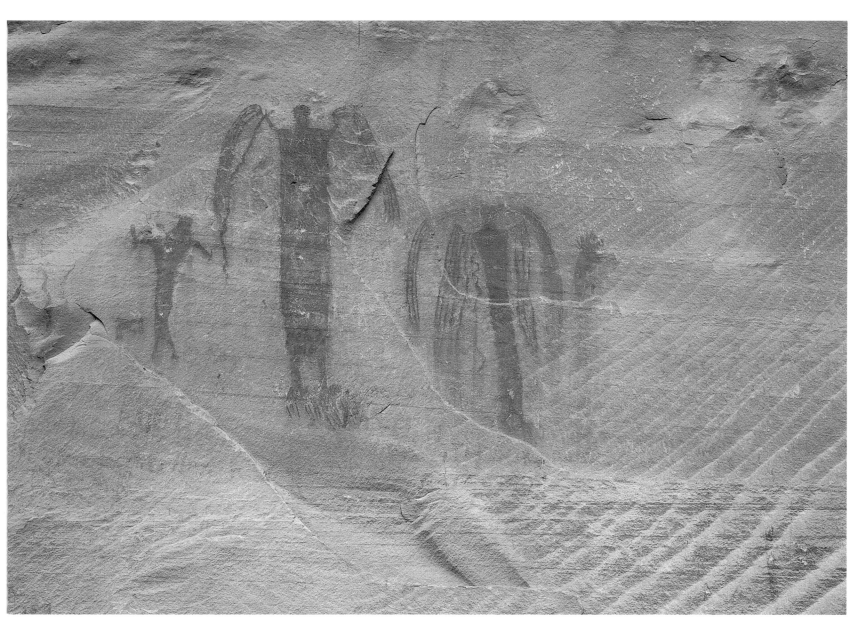

Plate 15
Buckhorn Wash Panel, **Barrier Canyon style, San Rafael Swell, Craig Law.**
Recently conserved by Emery County Centennial Committee, this heavily vandalized site
has recovered much of its original condition.

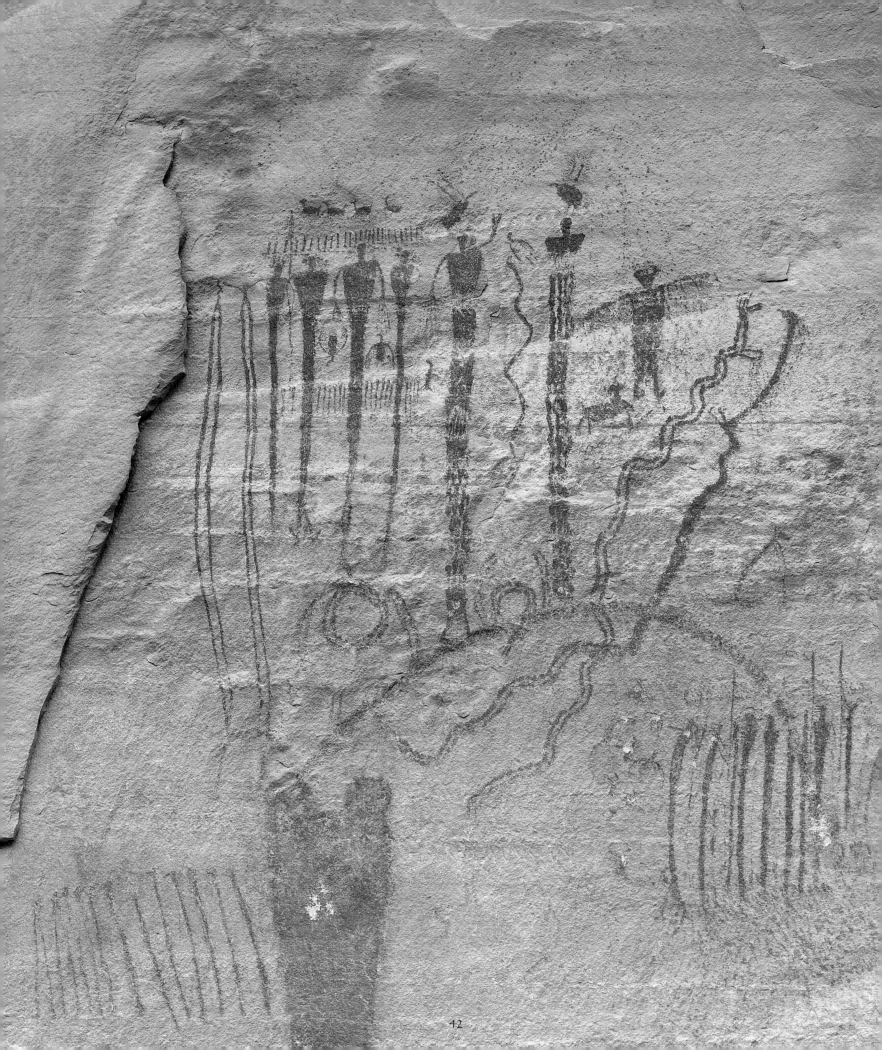

Plate 16

Buckhorn Wash Panel, Barrier Canyon style, San Rafael Swell, Craig Law.

This second detail features a tightly packed composition of sheep, birds, and snakes in close association with spirit figures about three feet tall. A smaller cluster in the right-hand corner shows figures with long spears.

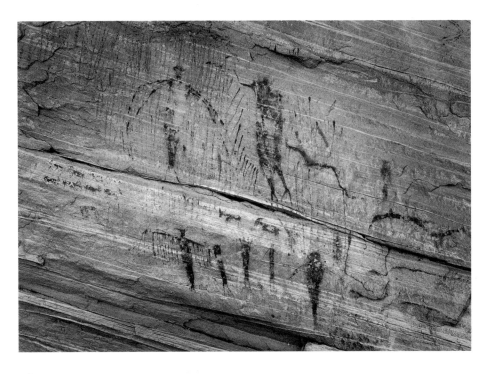

Plate 17

Prickly Pear Flat Panel, Barrier Canyon style, San Rafael Swell, Craig Law.

Some of these small hybrid bird-human images were drawn with chunks of red ochre.

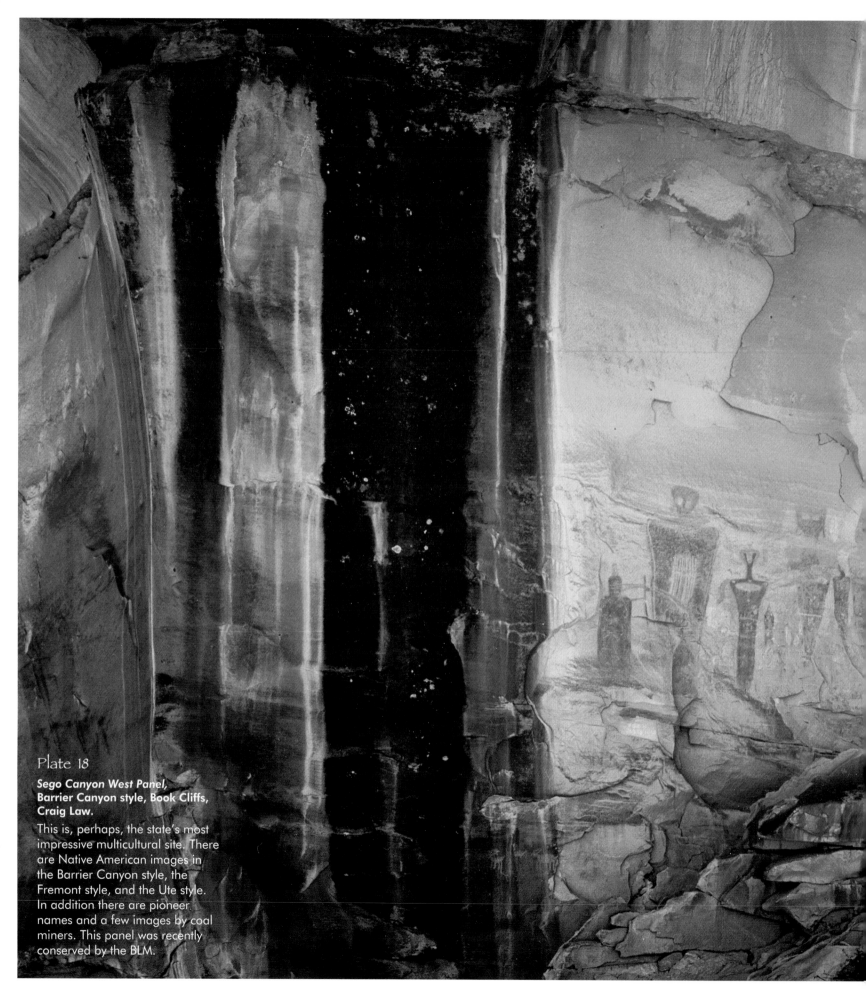

Plate 18

**Sego Canyon West Panel,
Barrier Canyon style, Book Cliffs,
Craig Law.**

This is, perhaps, the state's most
impressive multicultural site. There
are Native American images in
the Barrier Canyon style, the
Fremont style, and the Ute style.
In addition there are pioneer
names and a few images by coal
miners. This panel was recently
conserved by the BLM.

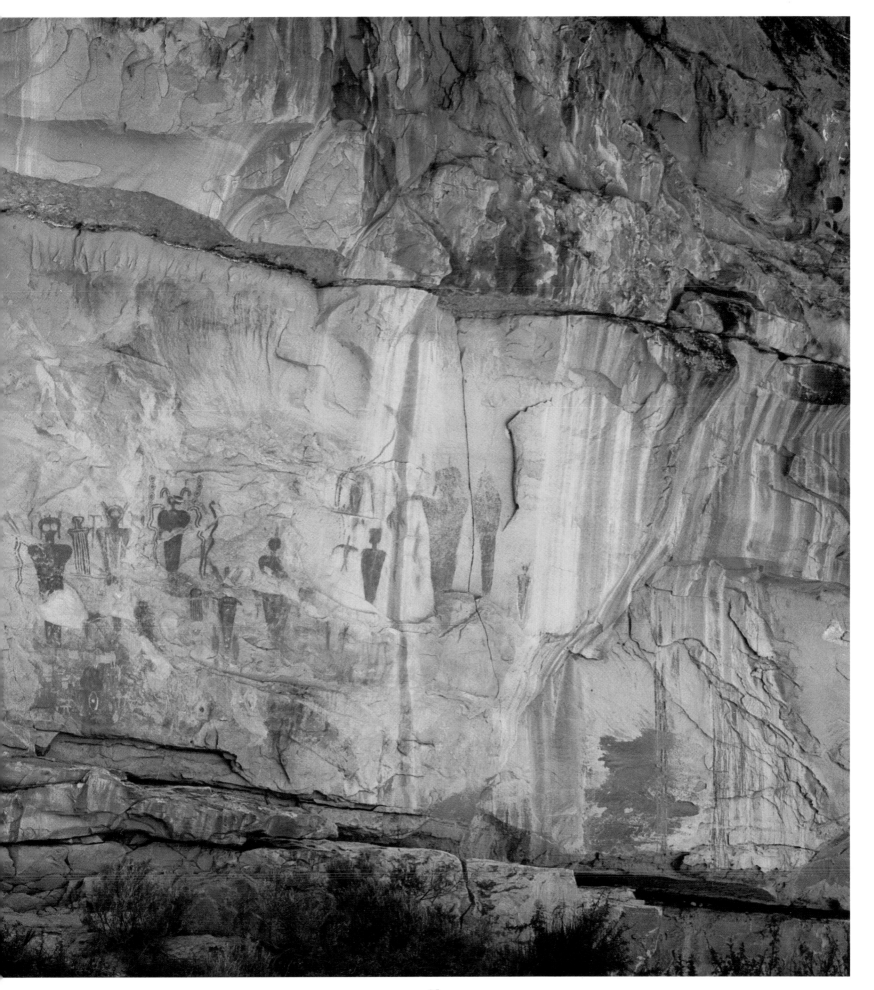

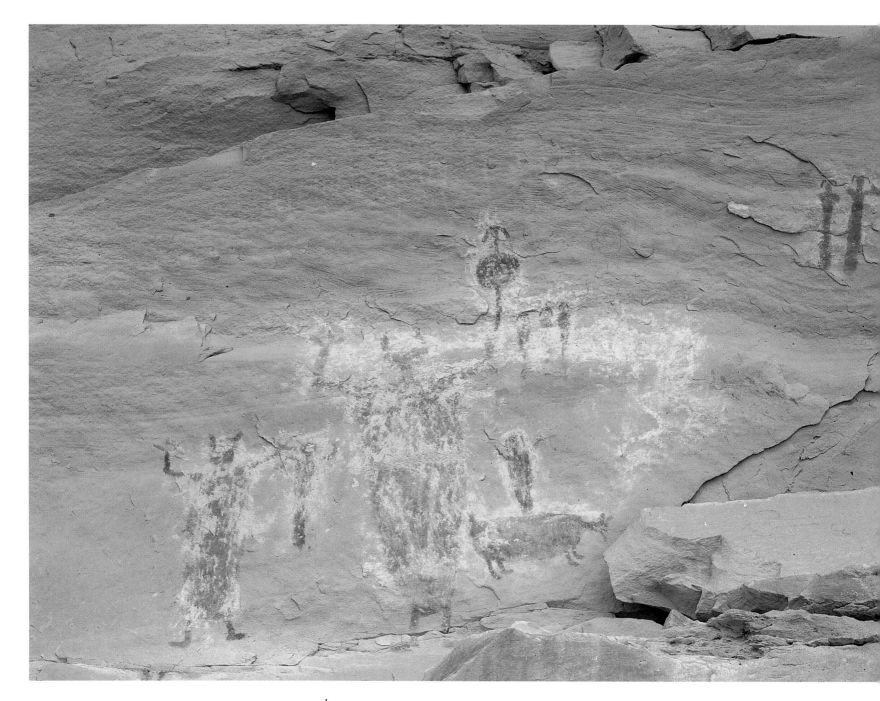

Plate 19

**Muddy Figures Panel, Barrier Canyon style,
Book Cliffs, Craig Law.**

The images have been partially covered by light
colored clay. It is not clear whether the muddying
was intended to partially obscure or create an
atmosphere, an ambiance, for the figures.

Some of these symbols were not put on the rocks by human hands. A spiritual being came into this world and put them there for those who want to connect themselves with that spiritual world. If you go there for a vision quest, you try to get yourself out there with it. You are meeting that and then you are going with it. For instance, there is a site in Wyoming on the Wind River Range. People that go there tell you: This was put here by a spiritual being. The powers of that are here, connecting with the mountains. So if you want to do medicine work or to become involved in ceremonies, that's the place you go. You ask that altar [for help]—as if it were alive—and you go through a vision quest, fasting and [going] without water for so many days. That's how you make contact with that.

The problem with the world today is that no matter how you try to protect these sites, people expose them. By Dinosaur National Park, or in Canyonlands or other places, the BLM likes to promote them for "public use." That's the phrase they use. We gotta' have people come in, they say. This is your land. This is your country. But do they really belong to those people? Sometimes you hear about people getting killed or dying, like the two young [mountain] bikers who got lost outside Moab. They were from back East and they died out there. I think something out there makes it that way. It takes those people— those bodies, you might say—in exchange for what they are doing.

So my question would be: Do they really belong out there? And how should we treat these sites? In talking about this, I think that would be good to bring out. These sites should be considered as being high level displays of religious activity. Just as in the Bible you have stories about Moses going up on top of the mountain and spending days and days [waiting for a revelation], this is equal to that. These symbols are the same. But a symbolic expression of a group of people does not start with the symbol as it is there, on the rock. It is something they believed in long before they placed it there. They put it on there as a reminder, or to establish a position—a sacred place.

Clifford Duncan
Northern Ute

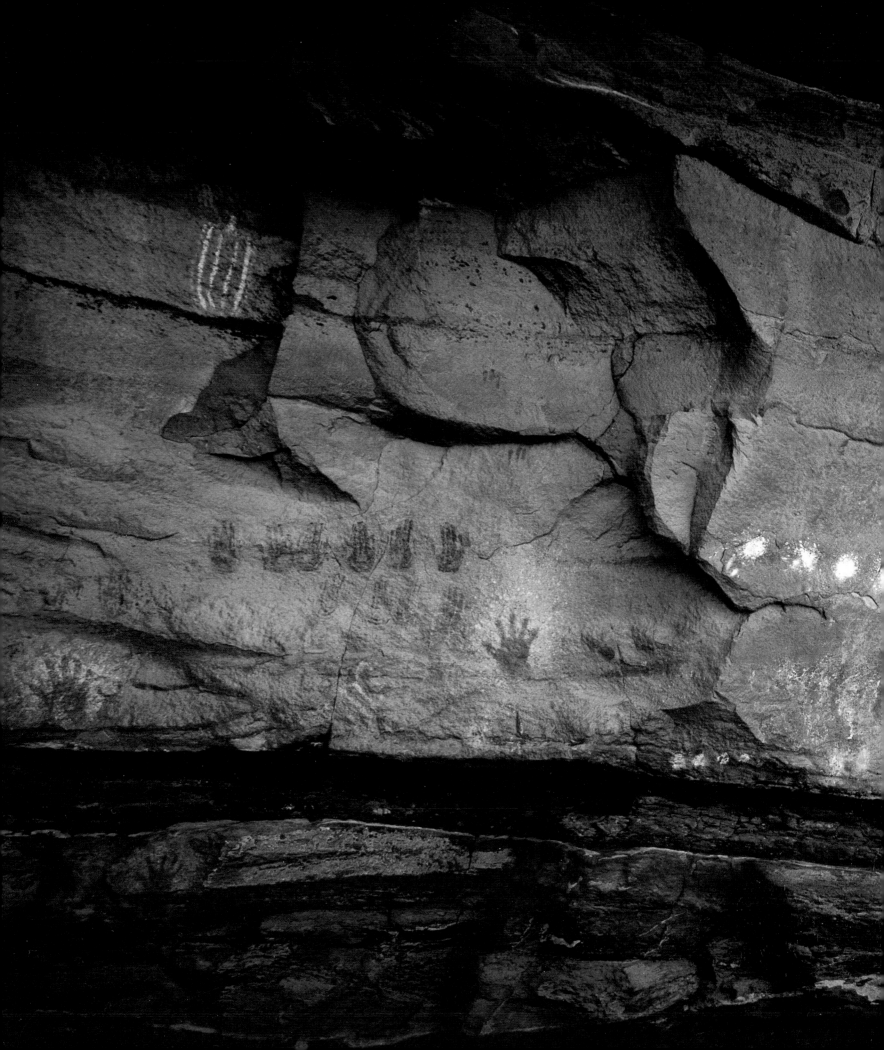

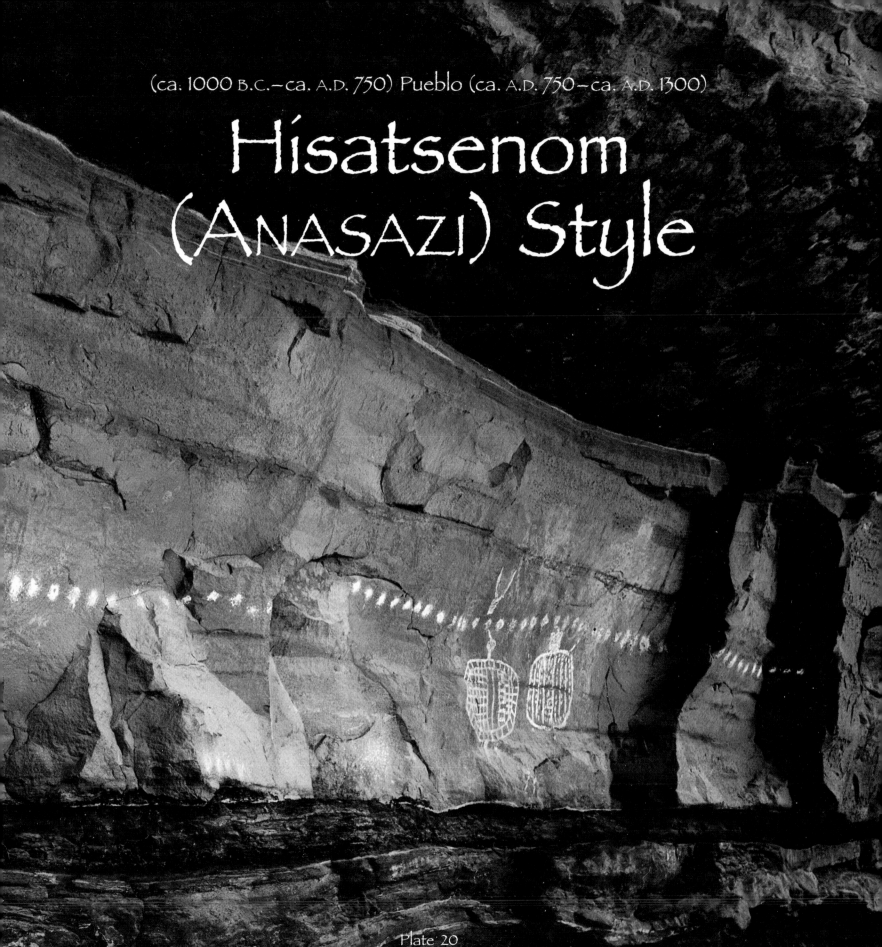

(ca. 1000 B.C.–ca. A.D. 750) Pueblo (ca. A.D. 750–ca. A.D. 1300)

Hisatsenom (Anasazi) Style

Plate 20

Peek-a-Boo Panel, Barrier Canyon style/Hisatsenom Pueblo, Canyonlands National Park, Craig Law.

Pueblo-painted images in white overlay faint red Barrier Canyon style figures (left center, far right). There could have been as much as 4,000 years between the two episodes of painting.

I know the scientific community doesn't really give credence to oral tradition. But from the Hopi frame of reference, information is passed down from mouth to ear, from generation to generation. Part of this information is retained and maintained in what non-Indians refer to as rock art. To us what is known as rock art is not art. It is a documentation of spiritual events that happened at various sites. It's also a documentation of what clans migrated throughout various regions that are embraced by the Hopi migrations. So when we as Hopi come upon a so called rock art site, we recognize the images on the panels because a majority of the symbols there we still use.

With regard to the Hopi migrations, each group or family that migrated was instructed to document through images on rock panels who they are, why they settled there, where they went, and to give indication of important events, spiritual and secular, that took place at the site. As a part of this migration process, each clan was instructed to go in their respective directions, to settle, to build communities, and to move on. Prior to moving on, they were instructed to break their pottery and scatter it about, because--the way I was taught--the day is coming when the people of the world are going to ask a simple question: Who are you? When that time comes, the Hopi will turn to the panels to explain the meaning and purpose of these documents.

So I was taught that these are our legal documents, our books. They explain who we are as a people, who we are as clans. Consequently, when people deface or destroy rock art, they are destroying our documented history. It is no different than me going into a city library and starting to burn and tear up books on Utah history, or going into the state historical archives and destroying those documents. Because that's exactly what's happening when people deface and vandalize rock art. And if you visit these sites, the thing you need to do is come with spiritual respect, because they are sacred sites. You had many spiritual events and ceremonies take place there. You had places that were dedicated as holy sites, so you have to humble and cleanse yourself. But the main thing to understand is that these are our ancient, historical documents. And they have to be preserved. They have to be saved.

Wilfred Numkena
Hopi

Plate 21

Upper Panel, Basketmaker, northern San Juan River drainage, Craig Law.

This large panel is one of two major Basketmaker rock-art sites situated within yelling distance of each other. The age, number, and density of images suggests extensive Basketmaker use of this area over a long period of time. Figures are near life size.

Representing a man and a woman—symbolically humanity—along with two ears of corn, this panel denotes the essence of the Hopi life plan. It says that the role of the male and female is the perpetuation of human life, and, that in order to fulfill this, humanity has to show utmost respect for the natural environment so that nature, in return, can support life through such blessings as corn. (Corn is the universal blessing handed to the Hopis by Ma'saw.)

In the upper right hand corner of the panel, there is a circle with four quadrants, depicting the four seasons. Below the circle, a man is planting seeds. To his right, there is a symbol of music required to maintain harmony with the environment. Below, there is the image of the rake which represents the earth; its teeth are the roots of the plants that helped the Hopi survive during their migrations.

On the left side of the panel is the symbol of the Reed Clan—the quail, and the Greasewood Clan—the roadrunner. This confirms traditional knowledge that these clans migrated through this region. This is their footprint.

Interpreted by Herchel Talahoma, Raymond Puhuyesva, Harold Polingyumptewa, Bradley Balenquah, Ruby Chimerica, and Leigh Jenkins of the Hopi Tribe.

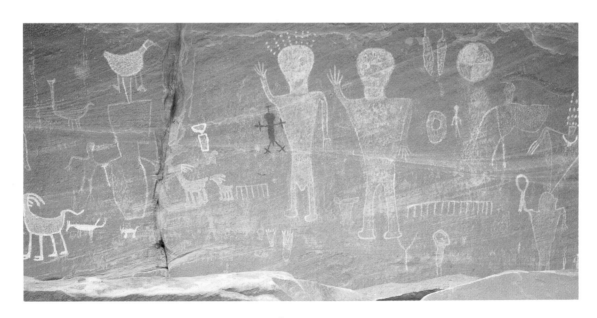

Plate 22

Lower Panel, Basketmaker, northern San Juan River drainage, John Telford.
Unlike the Upper Panel, which is aged but pristine, this panel has been seriously damaged by an irresponsible photographer. Chalking over rock art damages the fragile images, whether painted or pecked; therefore, it is not acceptable as an aid to photography. It is also illegal.

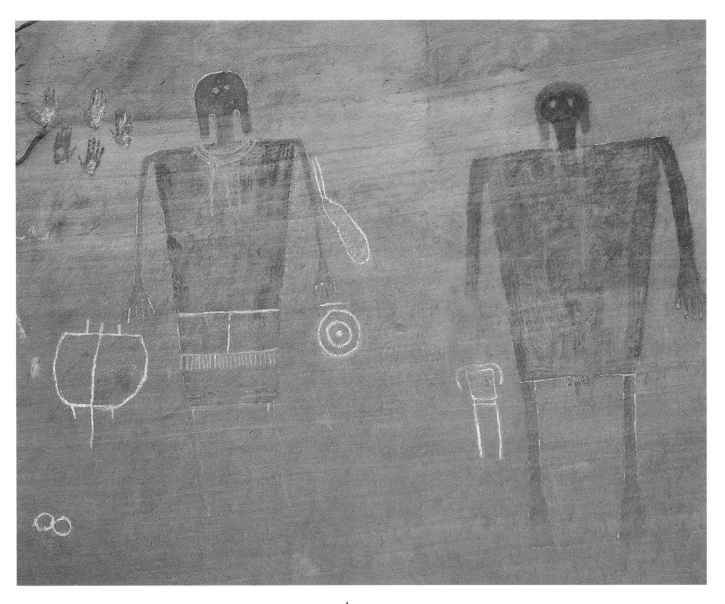

Plate 23

Basketmaker Panel, Basketmaker, northern San Juan River drainage, Tom Till.

The boxlike torso and fully represented splayed hands and feet are features
of Basketmaker rock art in the San Juan drainage. However, these painted figures lack the elab-
orate headdress typical of this style in panels nearer to the river.
Figures are about life size.

Plate 24

***The Green Mask,* Basketmaker, northern San Juan River drainage, Tom Till.**

This image, about life size, may be a representation of a ritual object made from a whole
face and hair scalp of a human head. One such skin, painted in a similar manner, was
excavated from a northern Arizona Basketmaker burial.

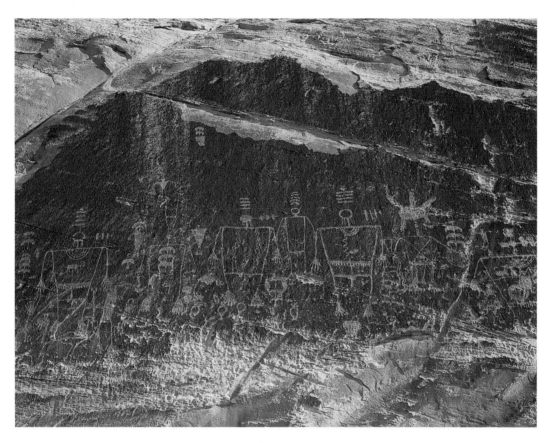

Plate 25

Butler Wash Panel, Basketmaker, San Juan River, Tom Till.

Heroic-sized figures, pecked into the black-brown patina, make this site
easily the most impressive large panel on the river. The elaborate head gear
(above and to the side) suggest Pueblo ceremonial headdress.

Plate 26

Basketmaker Panel, Hisatsenom Basketmaker style, Sand Island, Tom Till.
These small figures are part of a very large panel at Sand Island near Bluff. Although
these figures are in good condition, many of the images at this public site have been vandalized. The
flute player images with phalluses probably represent fertility figures. The "head" images
in the upper right corner of the photo are pecked versions of the painted head in
plate 24 (Green Mask Spring).

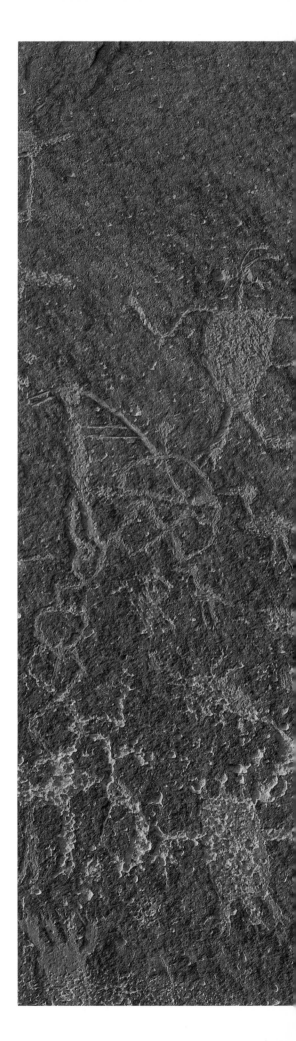

When Grandpa told me the story behind the flute, he said one of the main things it was used for was courting. Long ago, he said, a young warrior would go into council with a medicine man who would help him with the process of obtaining a suitable mate, or companion to be with. The warrior would obtain a lock of hair from the girl he wanted to court. He would bring this lock of hair to a medicine man who would wrap it in a medicine bundle, along with a bunch of herbs and other stuff. This enabled him to court this girl. He would then give this bundle to the warrior who would go out and play his flute.

It is said that only the girl he was courting could hear the flute. No matter where she was, how far away she was, or what she was doing, she would always be able to hear it. And she would follow the music and eventually come to the young warrior, and he would court her until the time came where he wanted to know if she would accept his hand in marriage. Then he would go out and kill a deer, or game of some sort, and he would place it in front of her home. If she accepted him, she would come out and prepare the meal and invite him over to meet her family.

This was one of the cycles of life that was described in the Ute courting story. The flute was also used for ceremonial purposes. In today's Pow Wow circle you can always hear somebody blowing the whistle or the flute, which sends out messages to the creator, asking him to send back blessings for those that are sick or that need extra help in their lives. This was the story my grandfather shared with me, as he showed me how to make the flute, so I could share it with others.

ALDEAN "LIGHTNING HAWK" KETCHUM
WHITE MESA UTE

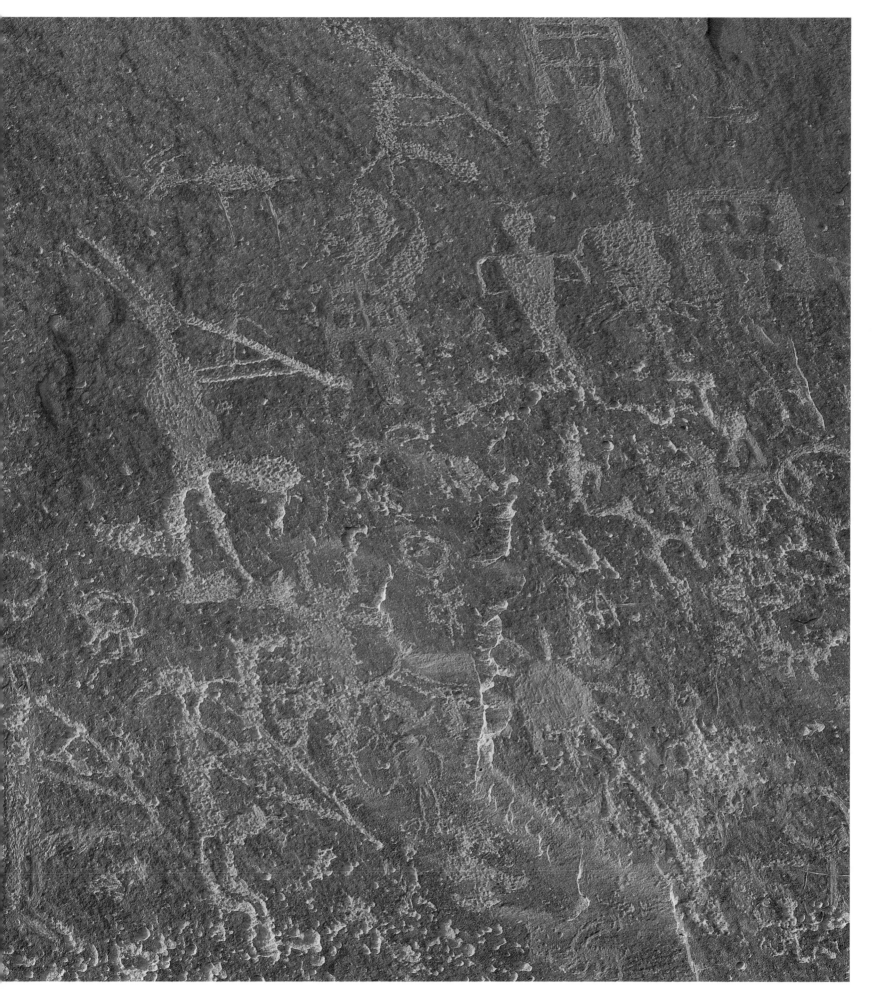

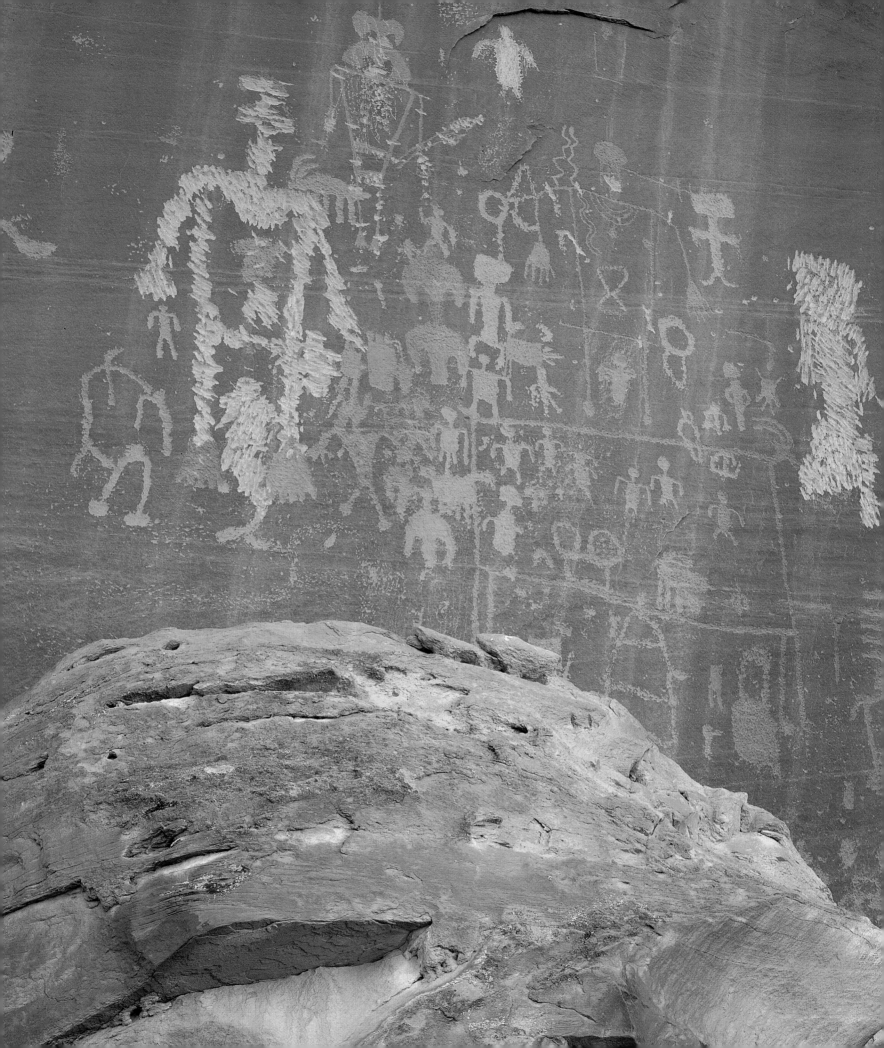

Plate 27

Desecrated Panel, Basketmaker, San Juan River, Tom Till.
On the south side of the San Juan River, this Basketmaker panel has been partially destroyed. It is reported that these anthropomorphic images were chiseled off during the 1950s by Navajos, under the direction of a local medicine man. Evidently, he felt that the petroglyphs were instrumental in the visitation of a serious health crisis upon the Navajo people in this area.

The Ute people did not bother the rock drawings. They knew the symbols of the old ones could be both harmful and good. They respected it that way and left it alone. Then, again, we don't bother anything that belongs to a person that is gone. At the old cemeteries, you'll find remains of articles which belonged to a person that's buried there. They are scattered about or put under a cedar tree. And they are usually broken in many pieces, so that they will not be used by anybody else . . . Like you might find a metate broken in half. Well, that belonged to one lady, one person. Her people broke it so no one would use it again, and they dropped it, and it's forever connected with the spirit.

They also figured only the people who were living there knew what it [the drawing] means. If it was bad, then something would come into your life and you would live with that forever. Maybe you would have bad luck, maybe something would go wrong. You don't want to live like that all your life. So that was the reason they didn't talk about it much.

It's simple to explain it this way. If you are in total darkness and you see a light, you are going to go toward that light because you'll think somebody is there. That's a human trait. They figured if you turn on a light at night, these spirits would come too. The light would draw them and something bad would occur. When you discussed them in your home, that also was like a light. It was like a magnet, and they would come. That's how that would work.

Clifford Duncan

Northern Ute

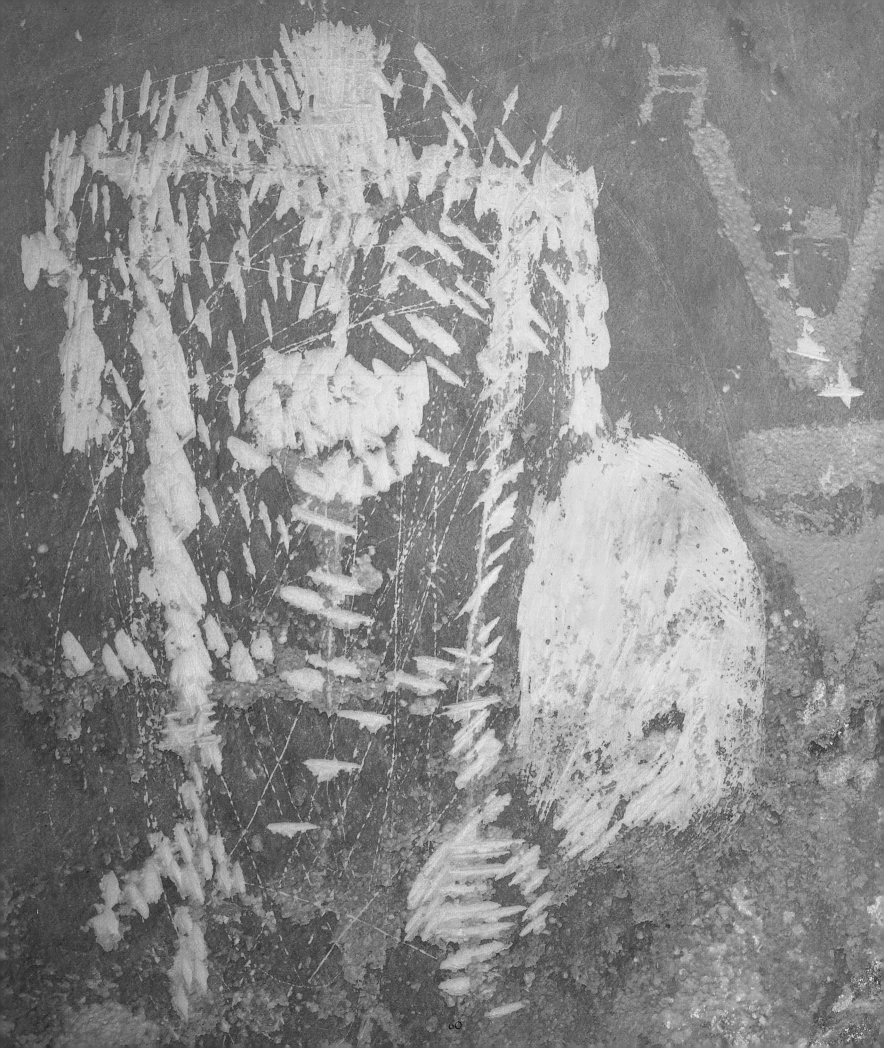

Plate 28

**Desecrated Panel, Basketmaker,
San Juan River, Tom Till.**

The large chiseled figure, on the left,
is unusual because of its "bird" feet
and its deeply pecked contour (most
apparent in the left shoulder area).

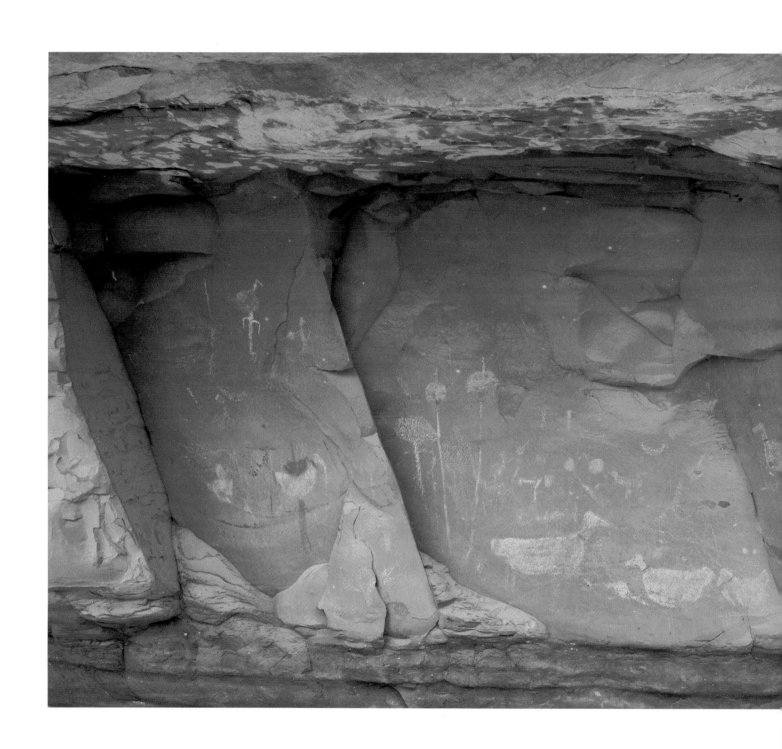

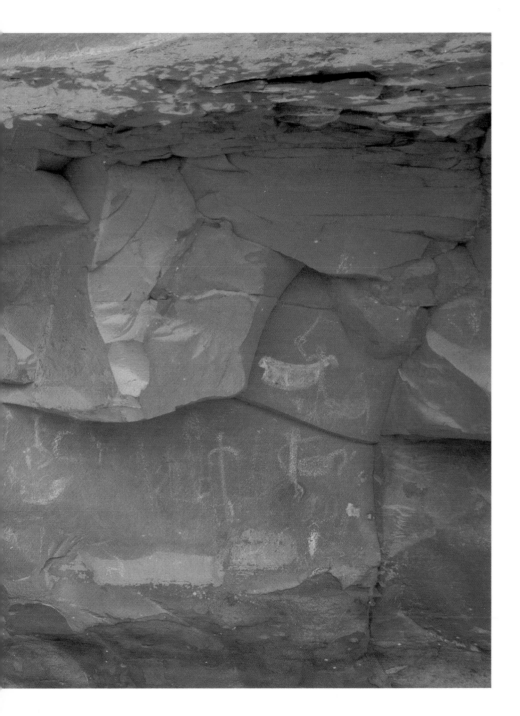

Plate 29

Dancing Panel, late Basketmaker, northern San Juan River drainage, John Telford.

This late Basketmaker panel features painted and drawn birds (primarily turkeys and ducks), atlatl forms, and anthropomorphic figures—often with large birds on their heads—in dancing postures. The large turkeys are about life size.

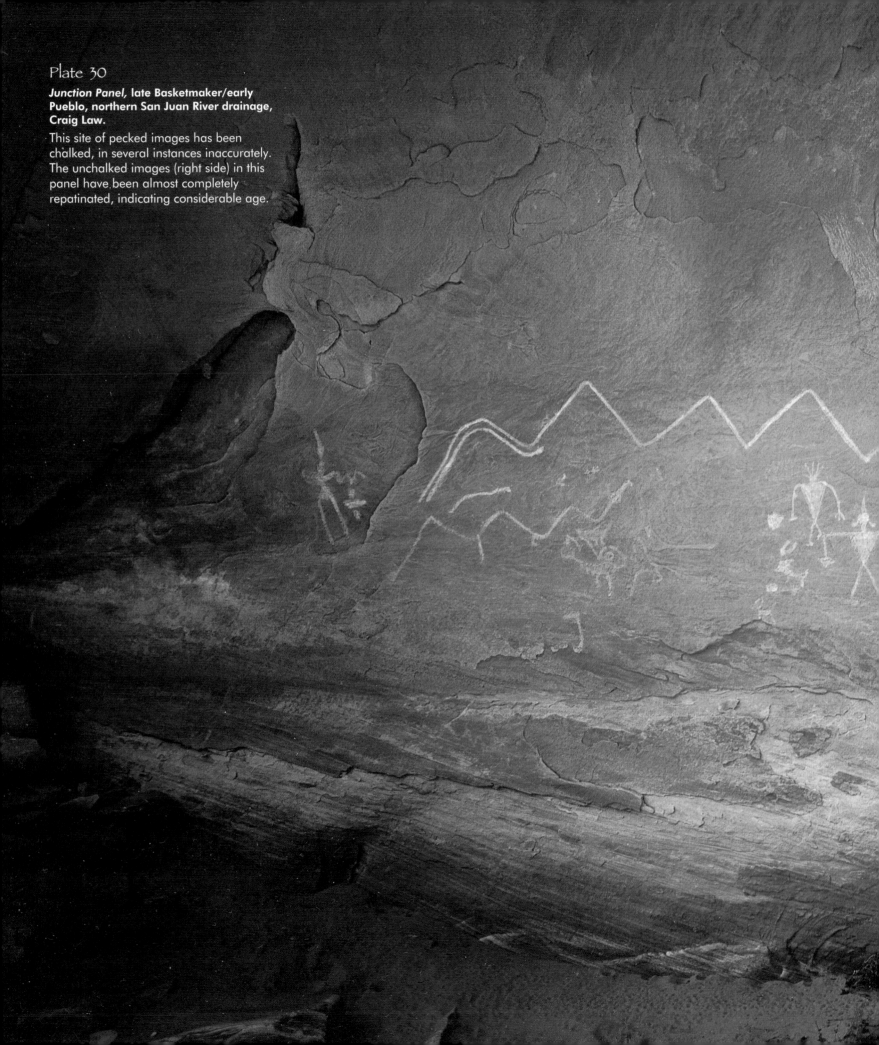

Plate 30

Junction Panel, late Basketmaker/early Pueblo, northern San Juan River drainage, Craig Law.

This site of pecked images has been chalked, in several instances inaccurately. The unchalked images (right side) in this panel have been almost completely repatinated, indicating considerable age.

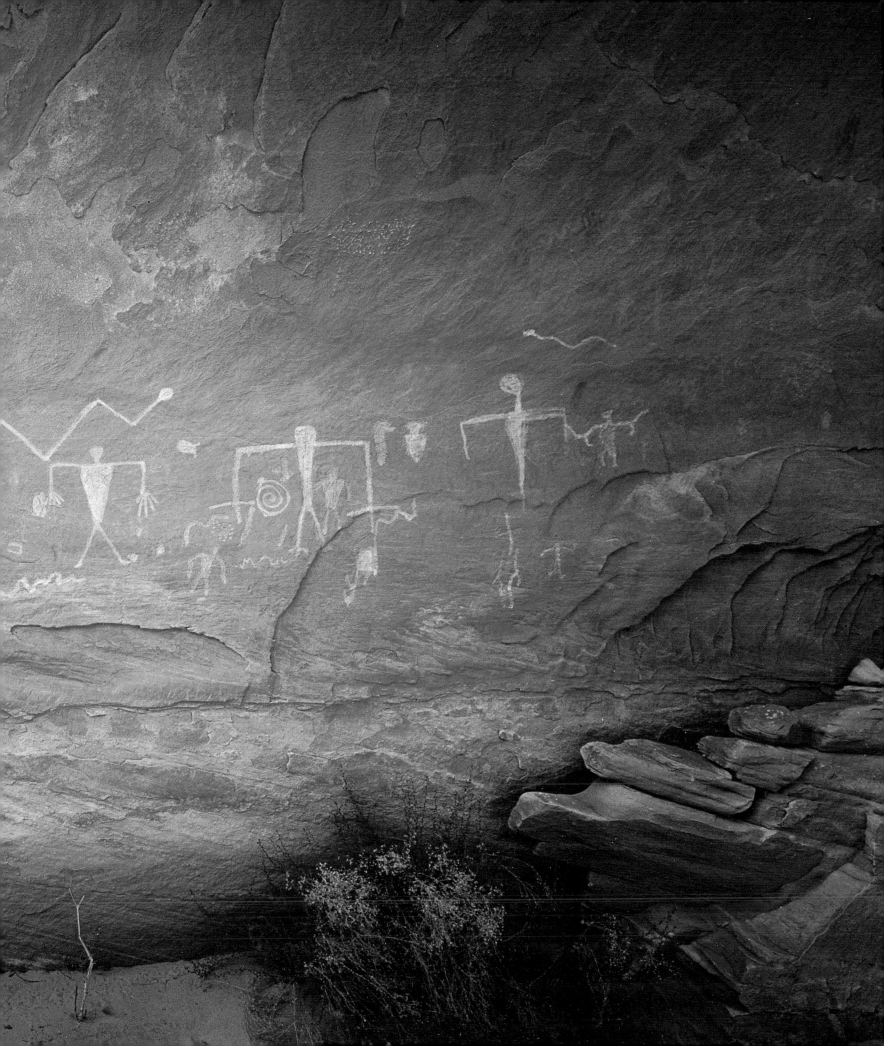

In my younger days, we had between eighty and a hundred sheep that we used to drive all the way up into Allen Canyon, close to the mountain. All through the summer, I stayed there with my grandparents and some of the young boys around there. We climbed every hill out there, took care of the livestock, and ran into our ancestors that were buried all over the canyon. Our grandparents told us to respect all of the burials, because there were a lot of burial sites. They told us, "If you see a burial, don't disturb it," because they didn't put them [people] into the ground that time. All they did was fold them up in a blanket and put them into a rocky area.

One day, we saw two anglos digging away in one of these big caves. We were sitting on top of a hill wondering: What are they doing? What are they looking for? They would invite us down for pop and we would see arrowheads and pottery. But we didn't know what they were doing because our grandparents said, "Never bother those areas. Don't bother what is left from the *Mokweetch*, because they will conk you back in the future." I saw big pots barely sticking out of the ground. But we never bothered them because our grandparents said: "It is theirs and [if you take it] it will haunt you."

My grandfather also told us, "Never run around at night. Before sundown hits, I want you guys in bed, in your camp." I asked him, "Why?" He said, "Because here in Allen Canyon, there are so many Indian ruins; there are so many *Weenuche* who lived in the area, and they are still here." He said, "If you get one of them coming up to you, you didn't do what I told you to do." I said, "Okay." So before sundown we used to hit the camp. And he came to town on these uranium trucks—you know, these trucks that hauled uranium to Blanding. He would get way on top of the dump truck, come into Blanding, get the groceries, and take them back out for us.

Norman Begay
White Mesa Ute

Plate 31
Handprint Panel, Basketmaker/Pueblo, eastern Canyonlands area, Craig Law.
Scores of red, white, and black handprints mark a shallow alcove deep in a side canyon of the Colorado River.

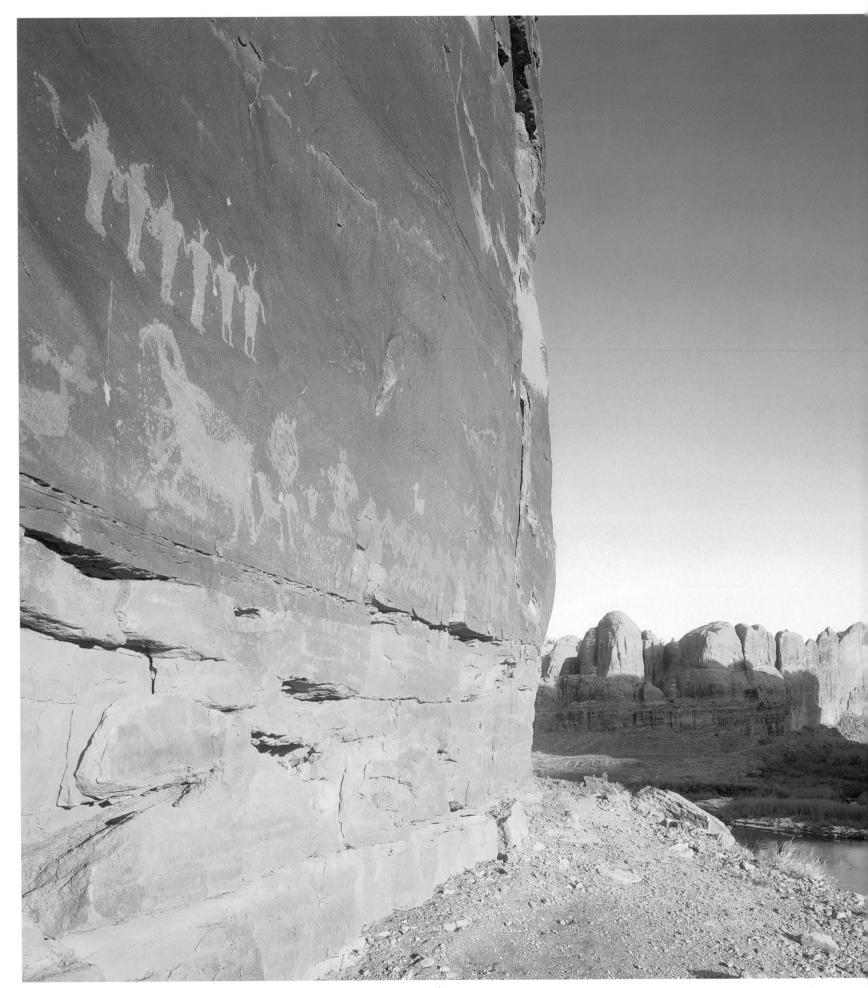

This figure is *Ma'saw*, the Hopi Guardian spirit and the spiritual caretaker of the Fourth World, our current physical life. According to tradition, the Hopis experienced three prior worlds, the last of which was destroyed by water. The ones who escaped the devastation emerged through bamboo shoots. After embarking at their Place of Emergence, the people moved off the shore where they met *Ma'saw*.

Ma'saw told them to follow their stars to the place where they would meet and settle. This is how it all began. Through the ensuing centuries—as the clans searched for their permanent homeland, the spiritual center of the earth—they traveled north, south, west and east. This image of *Ma'saw* indicates that he appeared to the Hopi clans during northern migrations to provide more instruction.

Interpreted by Herchel Talashoma, Raymond Puhuyesva, Harold Polingyumphewa, Bradley Balenquah, Ruby Chimerica, and Leigh Jenkins of the Hopi Tribe.

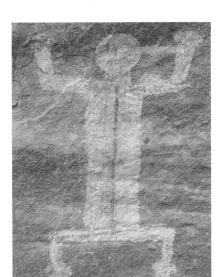

Plate 33

White Figure, **Pueblo, eastern Canyonlands area, Tom Till.**
This thickly painted figure appears to be a representation of the same entity represented by a carved stone figurine excavated in Pueblo II/III site in northern Arizona.

Plate 32

Dancers Panel, **Pueblo, Moab area, Tom Till.**
Sun basks this panel, while across the river, a light snow covers the ground in shaded areas. Large rock-art sites are frequently oriented to the south and the sun.

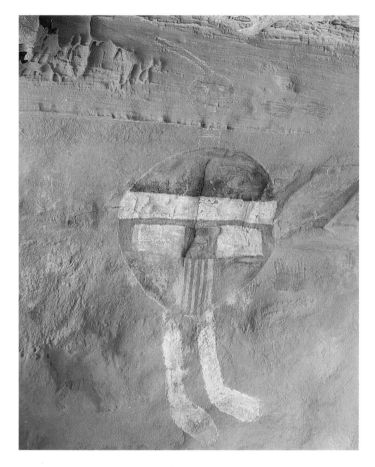

Plate 34

All American Man, Pueblo, eastern Canyonlands area, Tom Till.

Shield figures are seen in both Pueblo and Fremont rock art. This figure
was painted over much-older handprints.

Plate 35

**Five Faces Panel, Pueblo, eastern
Canyonlands area, Philip Hyde.**

Floating above the jumble of a rock fall, these
Puebloan paintings appear to be more in the San Rafael
Fremont style than in the Hisatsenom style.

Fremont Style (Uinta, San Rafael, Sevier)

I am from the Greasewood Clan of the Third Mesa, Bacavi Village. My clan traditions say we migrated from the San Francisco peaks [in Arizona] to *Tokonavi* (Navajo Mountain area), then north to the place of the rainbows, the Arches National Park. In Hopi, the natural arches are called rainbows.

We traveled with the Bow and the Reed clans. We followed them and together we were able to survive. The Bow clan was the most powerful clan because they held in their stewardship the Two-Horned society priesthood and the great Salako Ceremony. They also had as deities the two horned deity, *the Aalosaka* and the Katsina called the *Saaviki*.

Somewhere up north, we met with the Rattlesnake, Sand, and Lizard clans. Later, the Greasewood clan traveled east and met the Utes along the [present] Utah-Colorado border. We had a good relationship with the Utes. We traded, we hunted together, and we shared healing ceremonies. Later, the Greasewood people followed the Bow and Reed clans and settled near the village located in Mesa Verde National Park. We didn't live there. We made our homes nearby.

Based on this knowledge, the Greasewood clan has ancestral ties to what archeologists call the "Fremont" and "Anasazi" cultures. And we strongly object to the term Anasazi, which in Navajo means "enemy ancestor." We prefer the term *Hisatsenom,* which means "people of long ago," but properly interprets as *Hopi clan ancestor.*

LEIGH JENKINS

HOPI

Plate 36

Dry Fork Canyon, Uinta, Uinta Basin, Tom Till. The Dry Fork site consists of a series of panels and individual images along the east wall of a beautiful stream-fed canyon for a distance of about a half mile. The large figures, which can be more than life size, bear resemblance to the Basketmaker images 200 miles south.

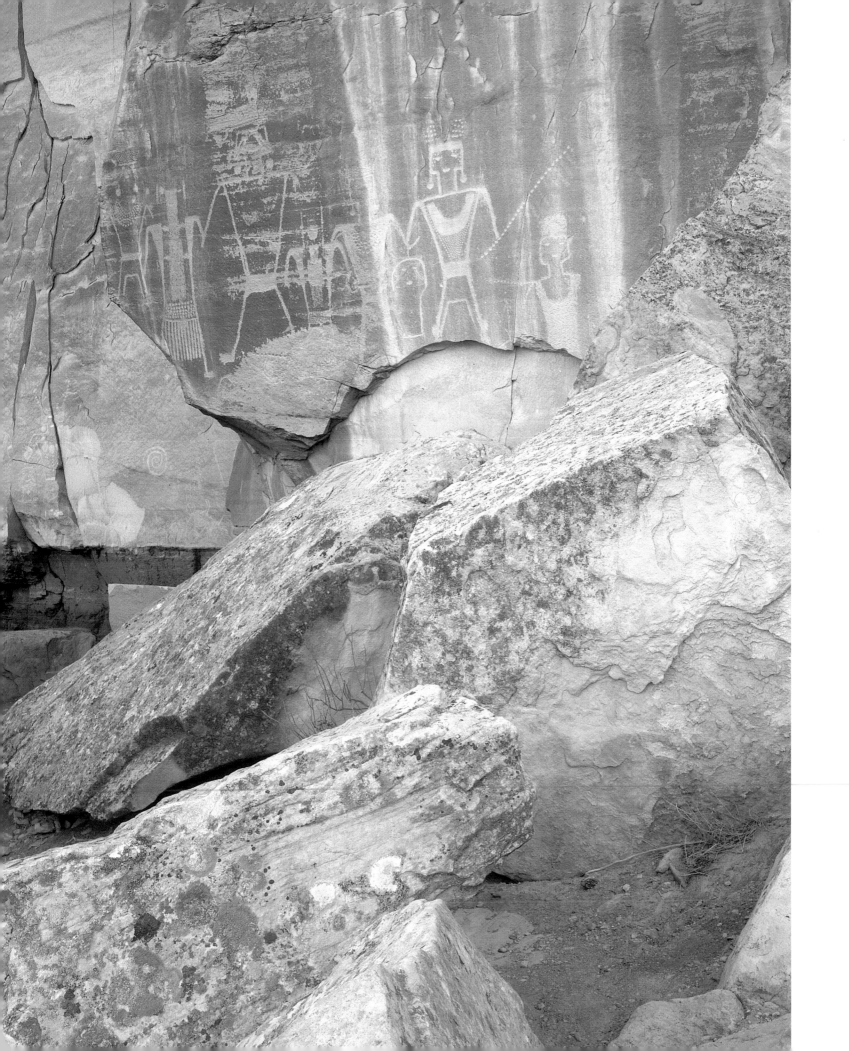

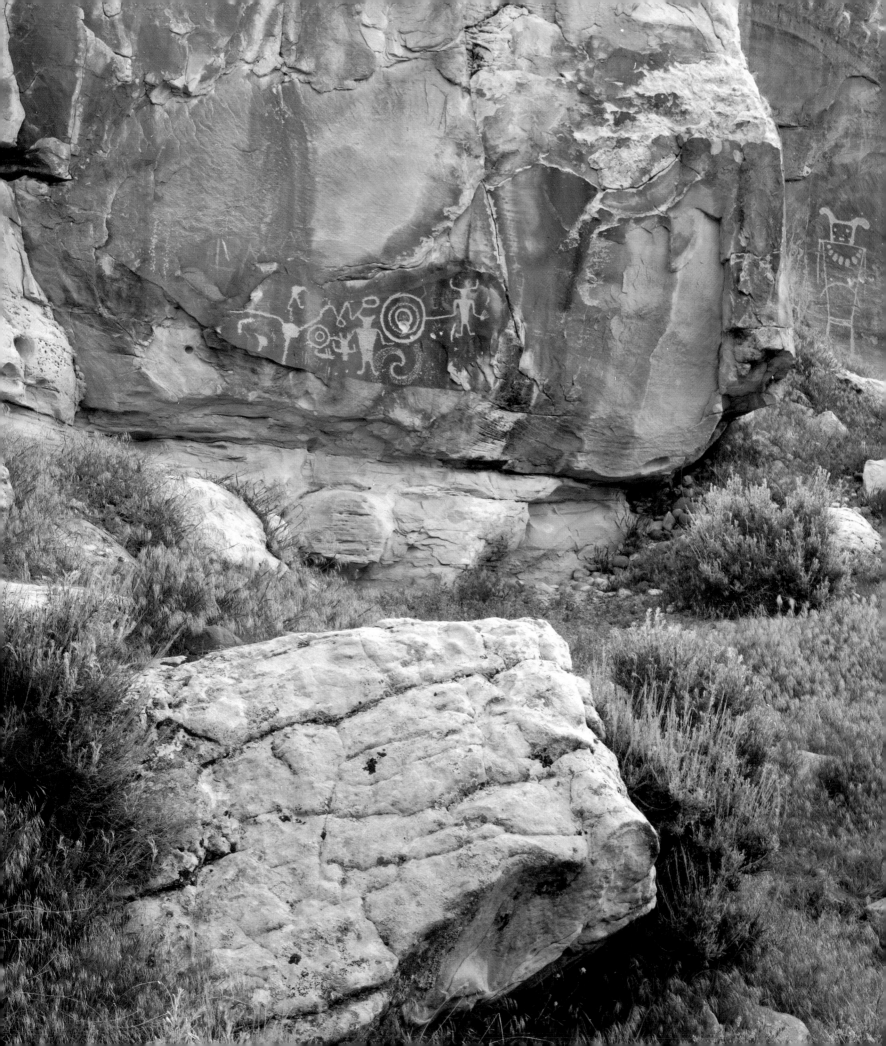

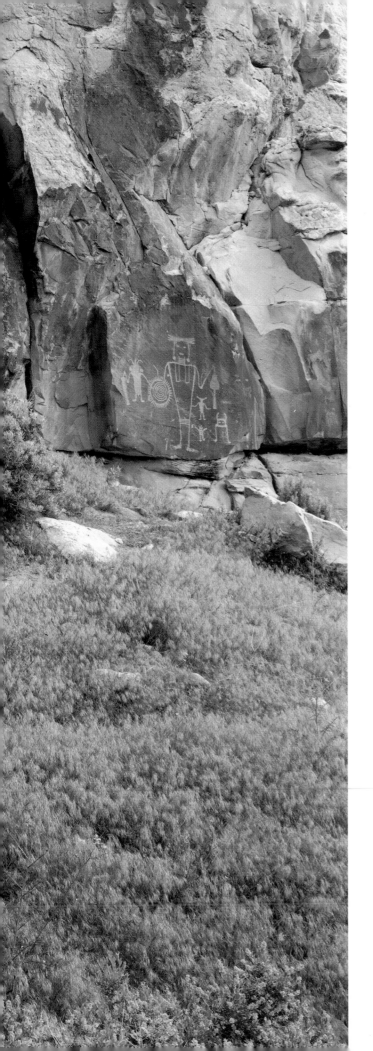

Plate 37

McKee *Springs,* Uinta, Uinta Basin, John Telford.

Another northern site consisting of several large panels. The typical life-sized anthropomorphic figures of the Uinta style are prominent in number and position.

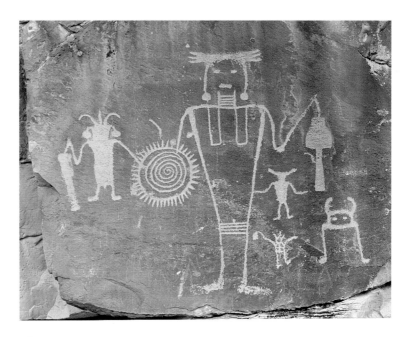

Plate 38

McKee Springs, Uinta, Uinta Basin, John Telford.

Consistent with the Uinta style, the anthropomorphic figures in this panel all wear different head gear. These two figures, typically, also hold unidentified objects in prominent positions. Occasionally, in other Uinta-style panels (plate 36), these forms represent heads.

Plate 39
McKee Springs, Uinta, Uinta Basin, John Telford.
Overlooking the spring, these images face the setting sun. The bison image has been superimposed over the bear's-ears mask at the right.

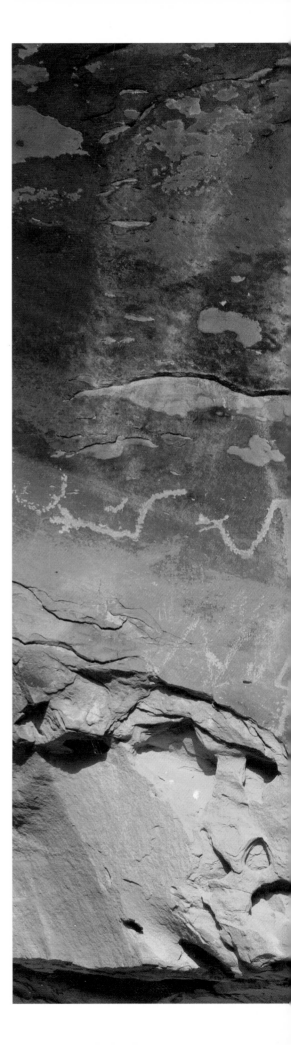

Where I come from, we have a medicine rock. We stop there often and leave sage, or tobacco, or money, and pray because that rock is powerful. I do that quite a bit. If I get into a down mood, I'll stop, pray, and leave money. It always seems to feel better. And when I leave that money, it means I am leaving an offering to the rock for giving me the strength to go on. This is my way of saying: I have taken something from you and I am leaving something in exchange. I never carve into it. I never damage it in any way. And I do not tell people who I think are sacrilegious where it is. That's all I have to say. I'm not a medicine man.

All I know is that in the course of my job [as a BLM archeologist] I would do anything to honor this area's tribes and these images. But I also honor the needs of whites who are sincerely drawn to these sites. I honor them because of what some old people told me. They said, "Those petroglyphs are there to heal people. When these white people go to them, they become happier. Some white people spend their whole lives looking at them, and it makes them feel better. It makes their lives more meaningful. So even though they are white, those rocks are healing them." So I don't consider these people a threat. Their interpretations may be out of this world. But the rock art is making them happy, making their lives meaningful; in a way, curing them.

MELVIN BREWSTER
NORTHERN PAIUTE

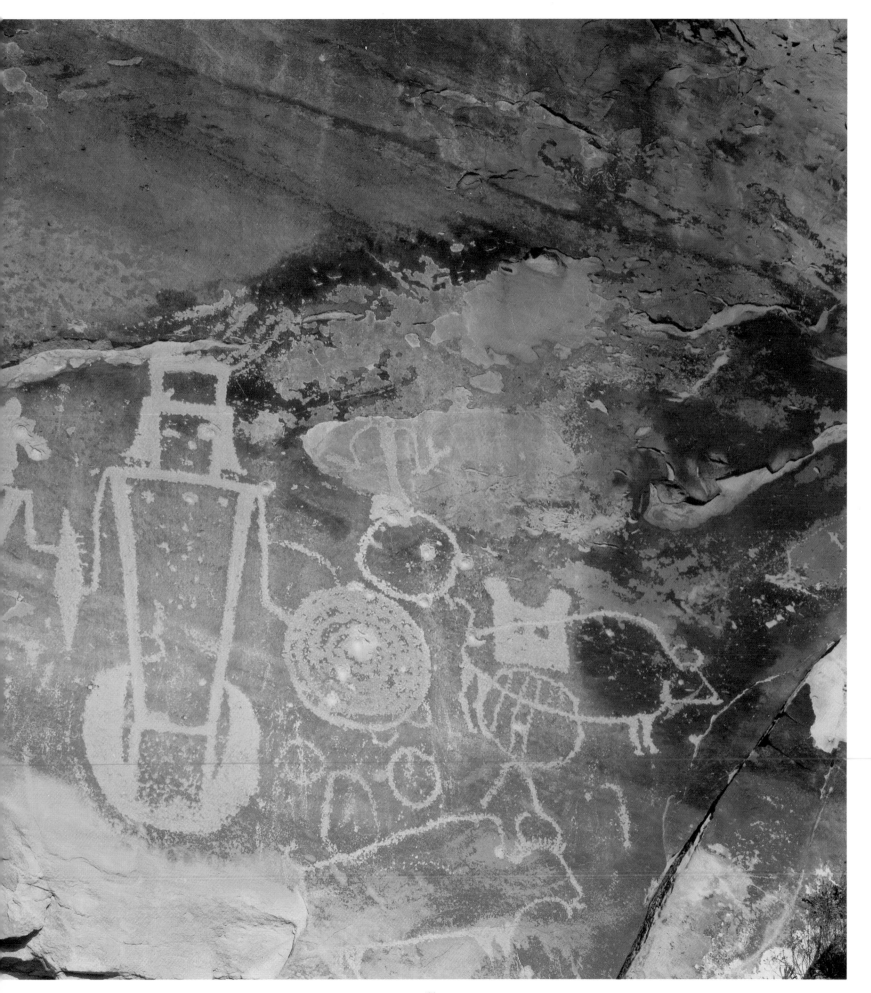

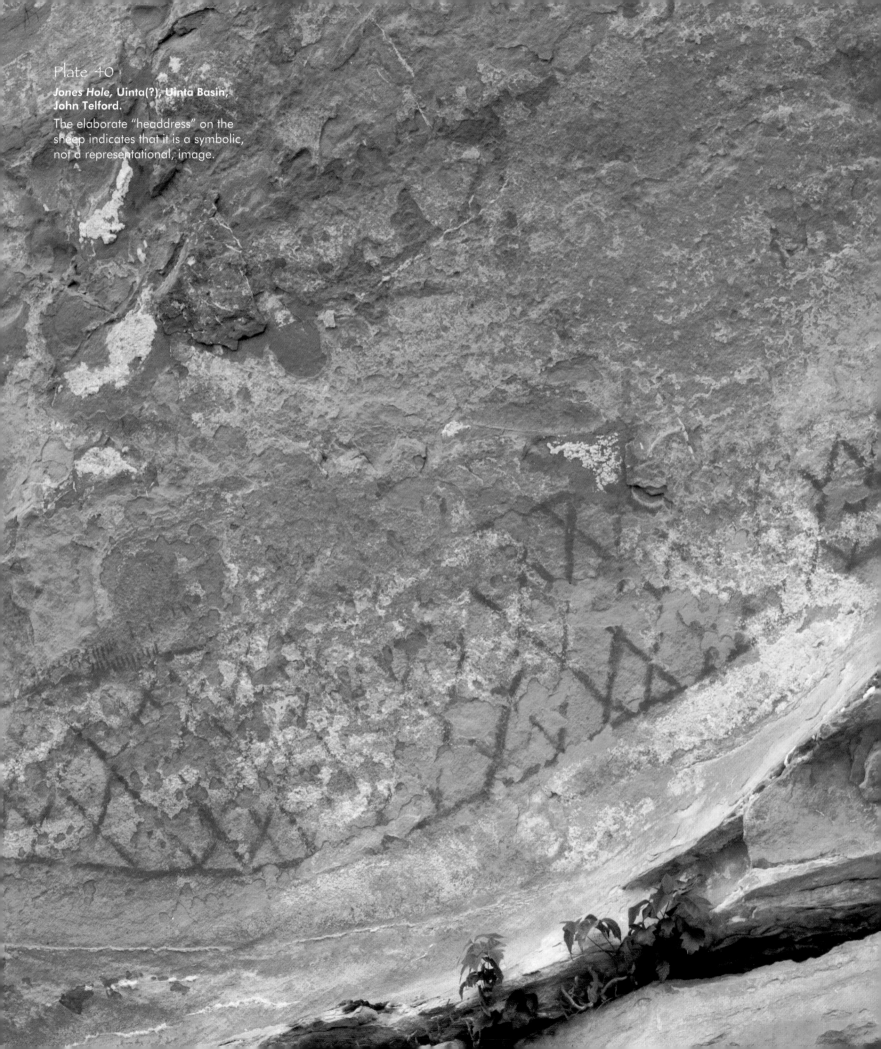

Plate 40

**Jones Hole, Uinta(?), Uinta Basin,
John Telford.**

The elaborate "headdress" on the
sheep indicates that it is a symbolic,
not a representational, image.

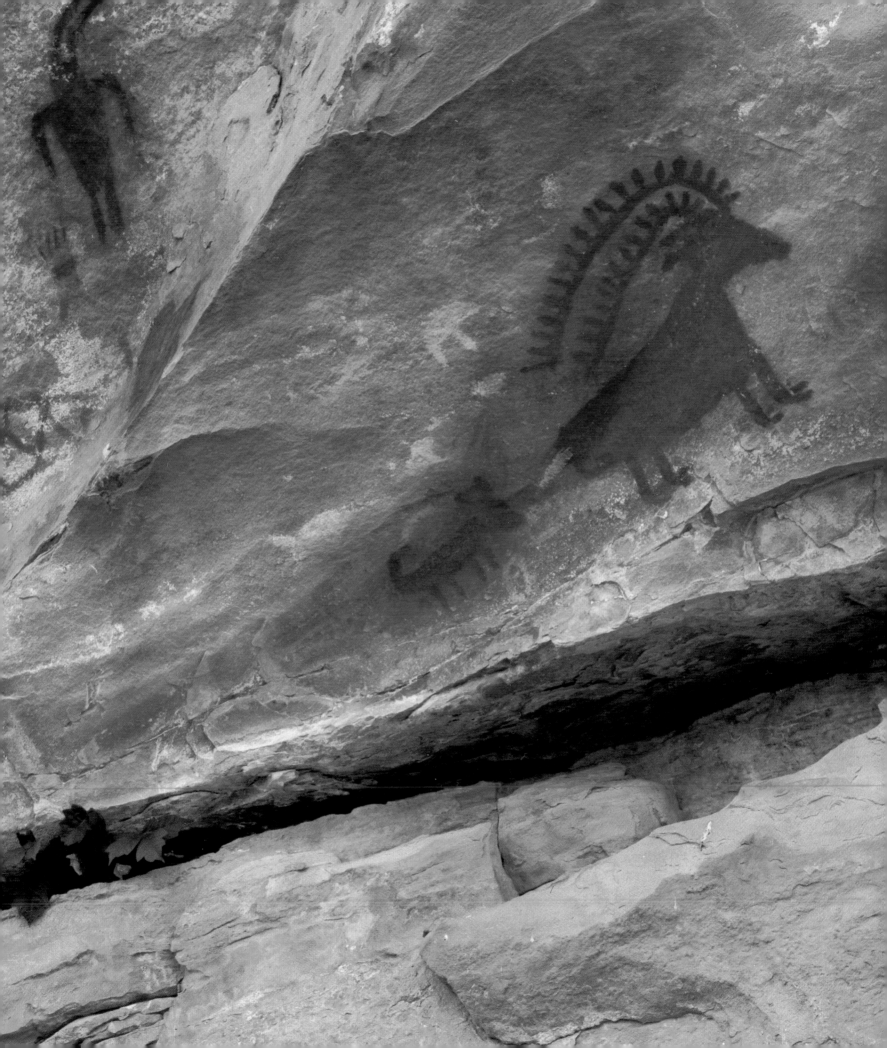

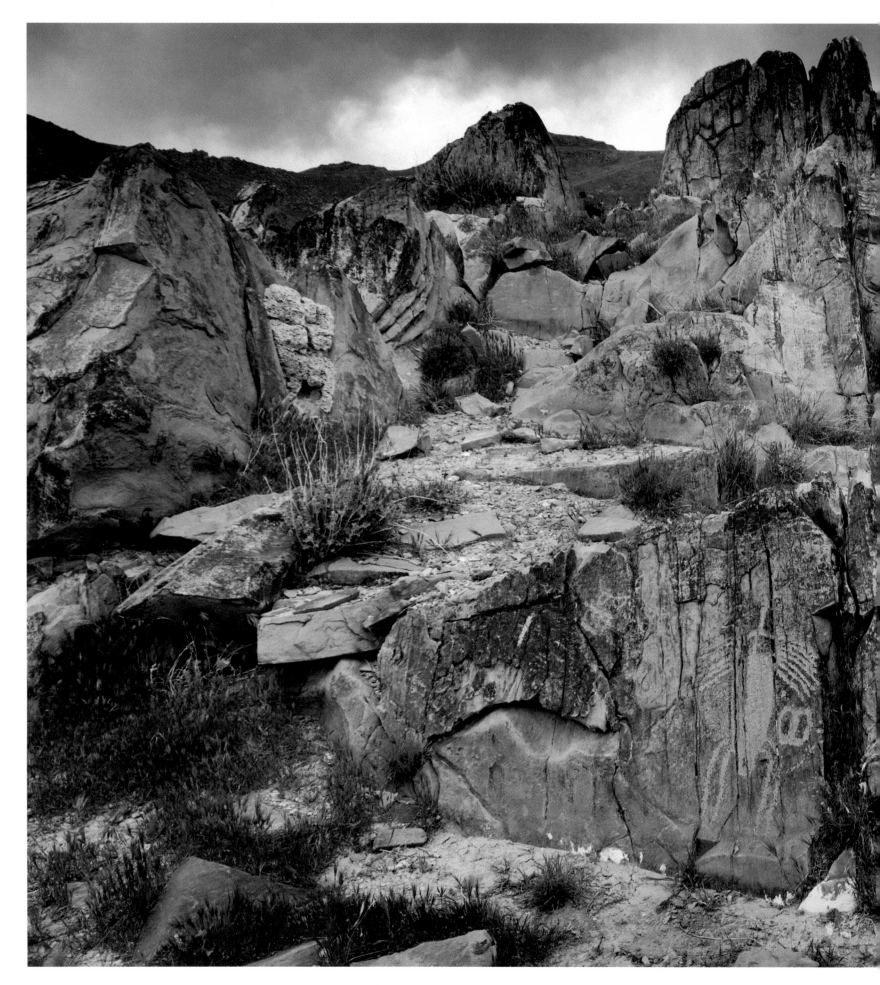

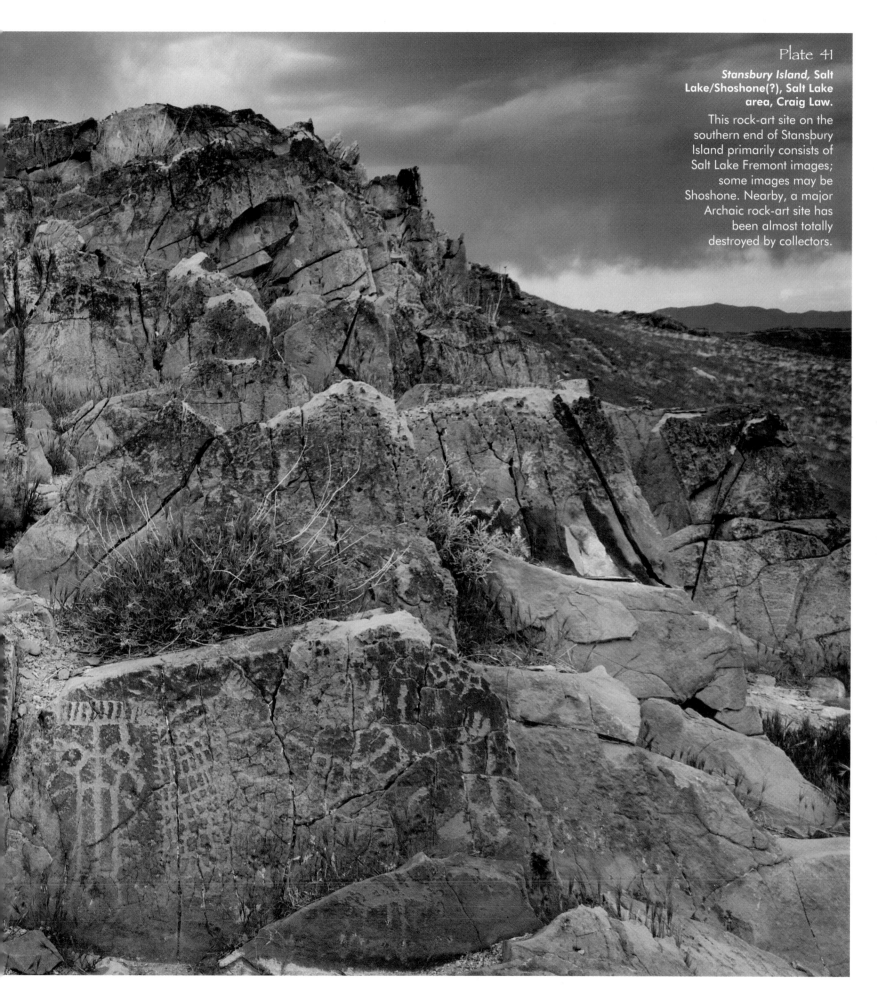

Plate 41

Stansbury Island, Salt
Lake/Shoshone(?), Salt Lake
area, Craig Law.

This rock-art site on the
southern end of Stansbury
Island primarily consists of
Salt Lake Fremont images;
some images may be
Shoshone. Nearby, a major
Archaic rock-art site has
been almost totally
destroyed by collectors.

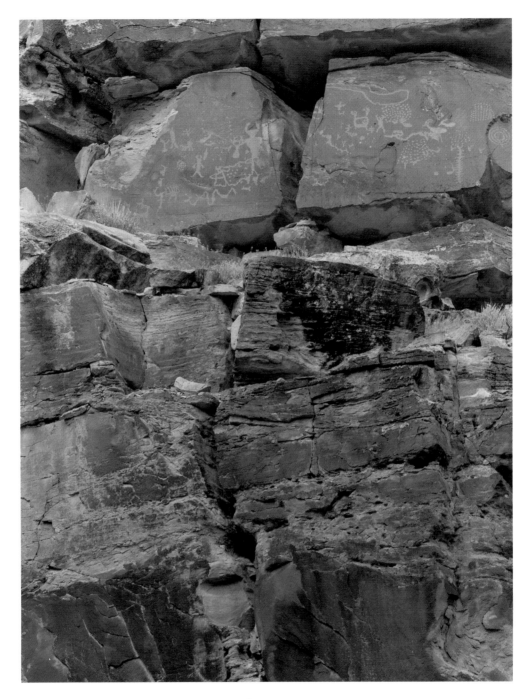

Plate 42

High Panel, San Rafael, Nine Mile Canyon, John Telford.

With hundreds of panels, Nine Mile Canyon, east of Price, is a veritable
museum of rock art. As in this case, many of the panels are located in high
and sometimes inaccessible places.

Many of our people went to the rock writings for medicine. If somebody had been sick a long time and wanted to be healed, people took him to the rock writings and left him there. This person would ask for the spirit to come and heal him. A lot of times they would get that blessing and be healed. A lot of times, though, there were Indians you'd call Doubting Thomases. They said, "Well, I'll go up there. I'll see if this is true." I have heard some old people say, "He went to sleep at these rock writings, and the next thing he knew, he found himself a mile or so away. And he couldn't remember walking away from there." But he found himself there because the spirits just threw him away. So you have to go with the right attitude; you have to be a believer. If you are not, they will get rid of you.

Mae Parry
Northwest Shoshone

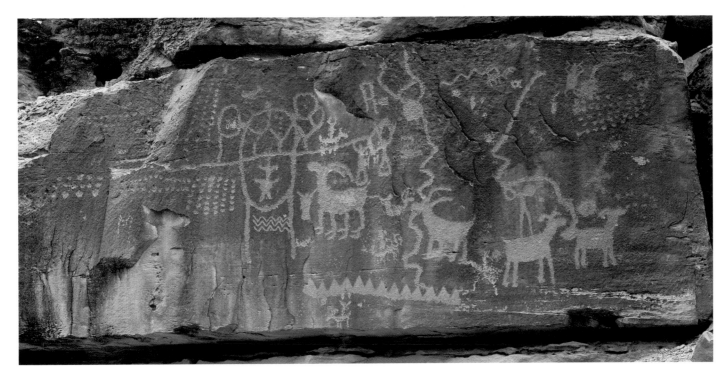

Plate 43

Oval Figure Panel, San Rafael, Nine Mile Canyon, John Telford.
San Rafael-style panels often consist of small anthropomorphic and zoomorphic images combined with nonrepresentational images and patterns. In Nine Mile Canyon, the natural blocking of the sandstone walls offers many pecking and painting surfaces.

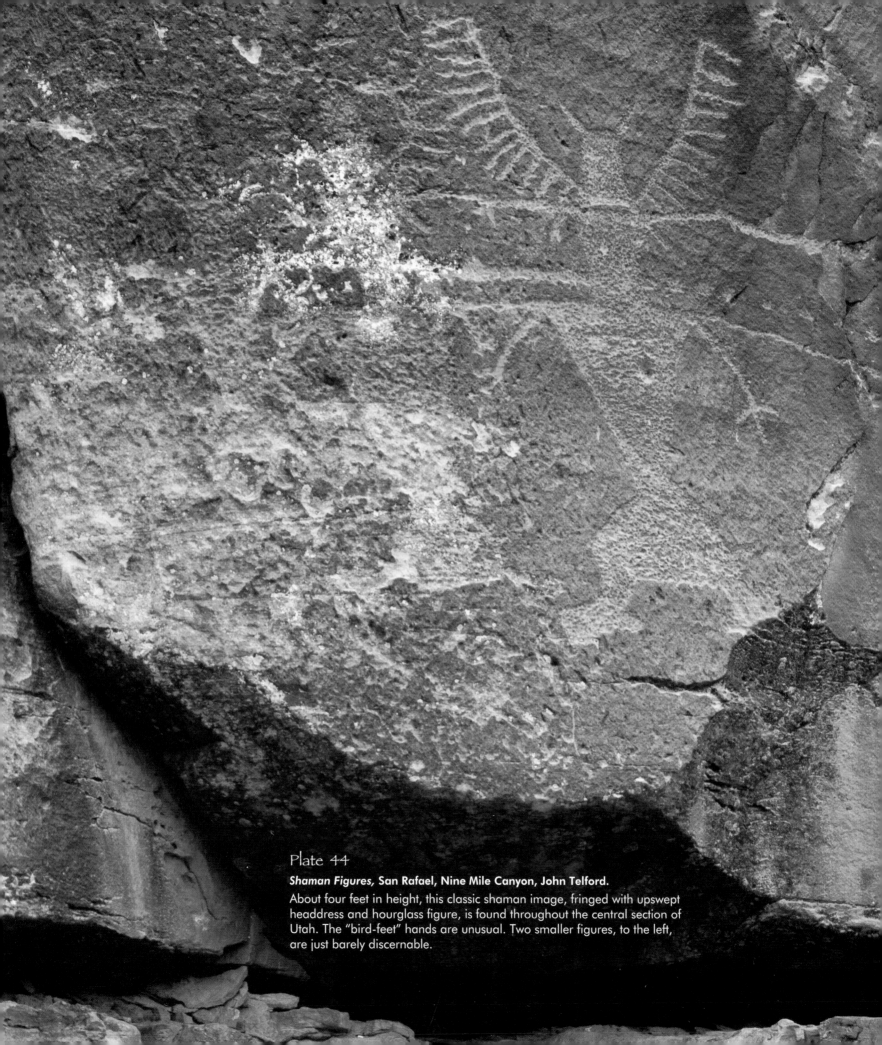

Plate 44

Shaman Figures, San Rafael, Nine Mile Canyon, John Telford.
About four feet in height, this classic shaman image, fringed with upswept
headdress and hourglass figure, is found throughout the central section of
Utah. The "bird-feet" hands are unusual. Two smaller figures, to the left,
are just barely discernable.

When they are put on the rocks in a ceremonial way, they are very special. They are helpers. I don't know this guy's name. I'm not sure where he is from. He could be from somewhere else, a different plane. But he is a good one. He's got a lot of power. He has three fingers with little balls at the end of each one. He has long arms and he has balls at the end of his antennae. I've seen him in a couple of places. I don't know why, but he pulls me there. I'll be pulled to a certain area, and there he is.

He's helped me in my medicine ways, and [showed me] how to find my trail. It's hard to explain. But he shows me how to step over into that other side and . . . see people's sickness. It's almost like looking through milky water, or through a milky gelatin. People sometimes look that way. But I can see inside. I see color and pattern. If it is a pattern that comes out of one point and spreads like an octopus, it is usually, but not necessarily, cancer. When it follows a blood line, it is almost like looking through milky Jello. The main thing is seeing the colors and what is happening. He helps me that way.

This same guy, I think, helped old man Bishop Arrowchis split these clouds. It showed him a red stick which grows in Sam's Canyon, way up on the hill. You get a piece of that, stick it behind you in the Sun Dance, and it splits them rain clouds. You shouldn't play with it because there is a reason the clouds come around. Something needs water. But during a dance you don't want it to rain on your people, because it'll hurt them. I mean, it'll just knock them out. So the best thing to do is to ask them to split the clouds up, so it'll rain on the other side of you, or all around you, but not on you. And that's the way of doing it.

DARRELL A. GARDNER SR.
NORTHERN UTE

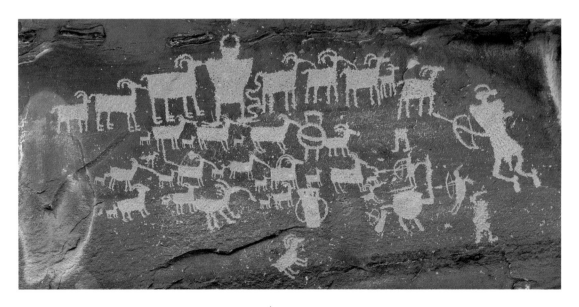

Plate 45

Hunting Panel, San Rafael, Cottonwood Canyon, John Telford.
This well-known panel is located in a side canyon to Nine Mile. The central figure here is
the horned, armless shaman (top center). The connecting lines between the sheep and two of the
anthropomorphic figures is an interesting feature. The large hunter on the right appears to
be wearing the skin of a bighorn sheep.

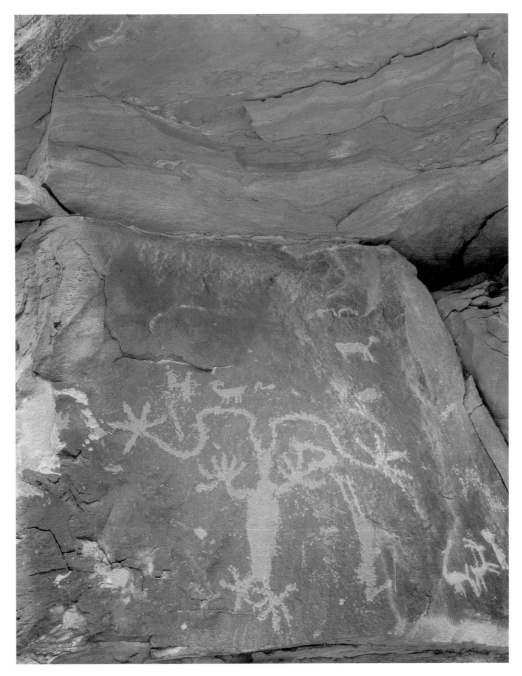

Plate 46

Supplicant Panel, San Rafael, Nine Mile Canyon, John Telford.

The larger figure, with lines ending in handlike forms, appears occasionally in the
San Rafael style. The kneeling figure, to its right, has arms upraised in the manner of a
supplicant. Everything in this composition suggests that the larger figure has
extraordinary qualities. It is smaller than life size.

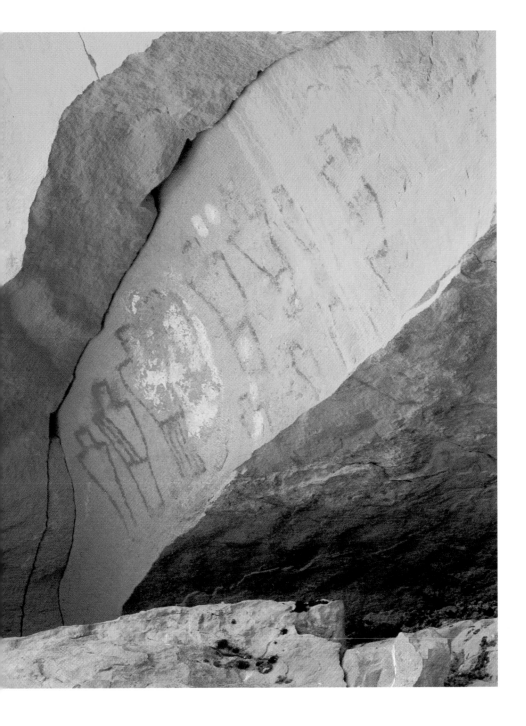

Plate 47

High Alcove Panel, San Rafael, Nine Mile Canyon, John Telford.

These armless and legless painted figures closely resemble Fremont figurines in form. There is also an interesting visual correspondence with Barrier Canyon-style figurines and painted spirit figures. The tallest image is about four feet in height.

Plate 48

Clear Creek Canyon Site, Sevier, Fremont Indian State Park, John Telford.

This extensive site consists of many panels. The canyon walls offered richly patinated and relatively smooth rock for pecking and carving. This site is the only rock-art site that is maintained and protected by the state. There are many more important sites that need similar attention if they are to exist into the next century.

In 1983, Travis Parashonts, the chairman of our tribe, wanted some assistance because the Utah Department of Transportation (UDOT) was building highway I-70 by Clear Creek. And the location was the site of [ancient Fremont] villages with petroglyph writings on boulders. I didn't know what I was getting into. But I was supposed to monitor this project on behalf of our tribe.

There were thousands of rock writings in this canyon. My job was to get our people up there to study the writing that was going to be destroyed.

It was pretty hard. We weren't all there daily. Even if we were, we might be on the other side of a hill, or in the valley, and the construction crew could still destroy a boulder to get going with the project. The bulldozer operators would tell us: "We didn't know what you wanted. Our boss didn't tell us." So everyone had to cooperate for this to go through, for us to document everything. That place meant a lot. You could feel it. But they didn't give us the time to study it.

We had two types of people we had to work with. We worked with UDOT officials, who wanted to communicate with us, although they might be ignorant. Then out in the field, we dealt with equipment operators, and they didn't give a shit. Their job was to make money and build a highway. Unless direction came down from their boss to slow down, they did not. Heavy equipment can tear. As the bulldozer approached a certain rock, the guy's mind might have been wandering. I'd step away and he might just cruise on through, then say, "Oops, it's destroyed." People can be ignorant like that.

We had to work with people who just could not accept us looking into the past to try to understand what is in that canyon before they could continue working. "Let us get it done," we kept saying, "then you guys can build a highway." But they could not understand that.

ALEX SHEPHERD

PAIUTE TRIBE OF UTAH

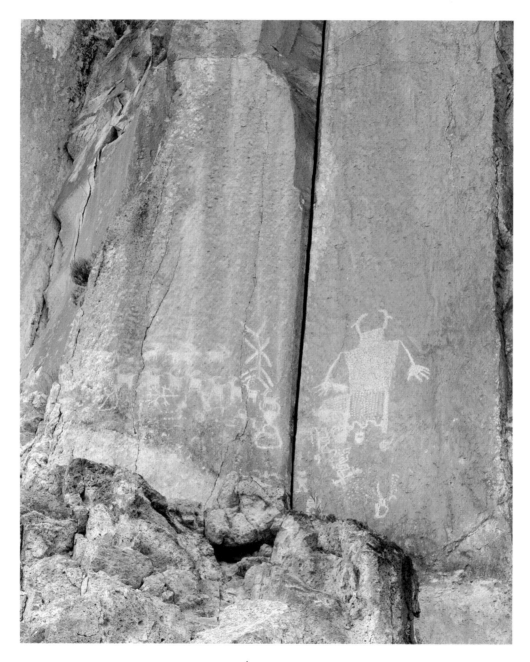

Plate 49

Shaman Figure, Sevier, Fremont Indian State Park, John Telford.
Like the San Rafael style, rock-art panels in the Sevier style exhibit a mix of
representational and nonrepresentational images. Large anthropomorphs tend to
be about three to four feet in height.

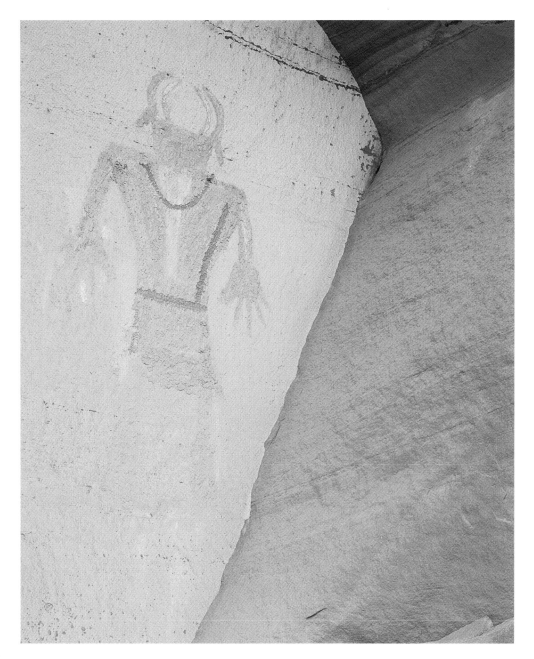

Plate 50

Painted Figure, San Rafael, Escalante River drainage, Tom Till.

The Fremont anthropomorphic images in the Capitol Reef area have marked
similarities to Uinta style in form and body design. However, the addition of the hands
and feet suggests a Basketmaker influence.

Ute Style

There are symbols which tie in with the world at sunrise or sunset. South of Rangely, [Colorado] there is a panel of a tepee. The door faces to the east, and it is done by the early Ute. I came down there one evening and sat overlooking this site, and I could see there was a tepee there. A little one. There were specks above it, here and there. When the sun set, the tepee looked like it sat on the ground. But from where I sat, the background turned into the sky because the stars on the rock blended into the sky. So I had the feeling that the man who put it there connected his world with the outside world. There are places like that.

In most cases, when I visit these sites, I'll leave an offering of tobacco, because these are spiritual symbols and you are connecting yourself with the symbols. And when you receive something from them, you offer something from yourself. Some people will give an offering of corn pollen. They use that like I use tobacco and put it on the ground under these people. And to me [then] they become real. I talk to them.

In medicine work or spiritual work, you have to put yourself in front of this figure and say: You are a man and I am a man, too.

Accepting this, you pray to it, you talk to it. And you keep in mind that you receive from it. It talks to you. This reminds me of a story. A lady once told me this: When you are talking to God, they call that praying. But when God talks to you, they call that schizophrenia. So the scientific meaning has changed people to where they don't believe. If it can't be proven, they say, it's not true. But Indian people who work with these symbols have to get away from that because for them it *is* real, even if it has never been proven. For them, the world is still alive. All things have a spirit; therefore, these have a spirit too.

So I will leave an offering because I look at this as an altar, a place where a person should go for spiritual answers or even for healing to take place. And you have got to go there for this to occur. And you have to think [of it] the way it was meant to be. Then you will become a property of it, and it will become a property of yours. But [you do not damage it]. You leave it for others, because it is not for one person alone.

CLIFFORD DUNCAN

NORTHERN UTE

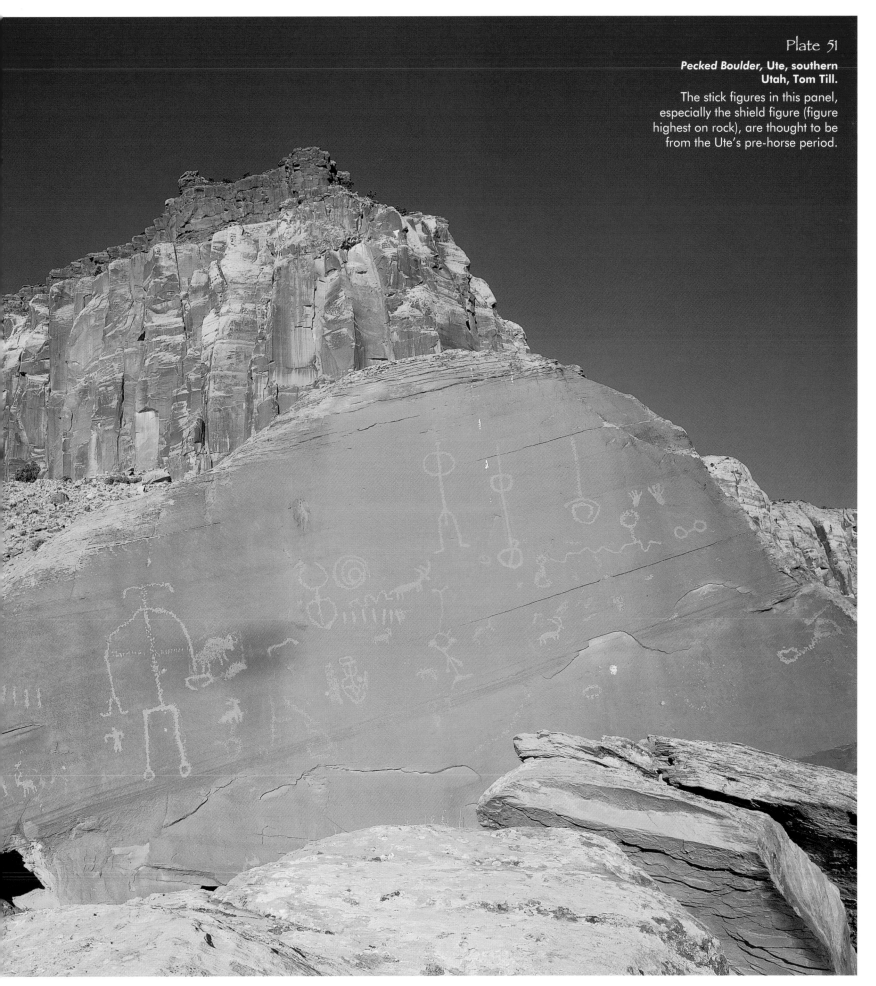

Plate 51

Pecked Boulder, Ute, southern Utah, Tom Till.

The stick figures in this panel, especially the shield figure (figure highest on rock), are thought to be from the Ute's pre-horse period.

Plate 52

Newspaper Rock, Ute/Fremont/Hisatsenom, eastern Canyonlands area, Philip Hyde.

A popular stopping point, this fenced-off site has a layer of Ute images pecked over older images of Hisatsenom and Fremont. In fact, Utes have refreshed some of the older images by merely repecking them without any modification (e.g., horned anthropomorphs, top center).

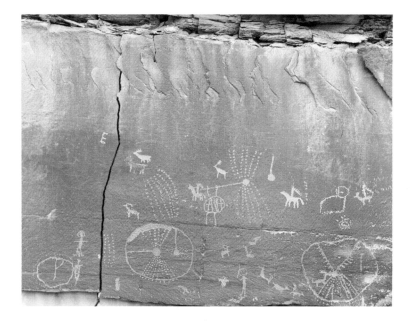

Plate 53

Shield Panel, Ute, Nine Mile Canyon, John Telford.

Shield patterns are unique to the individual who creates them. This panel is particularly interesting because the unfinished shield image (upper, center), when finished, would have been the same design as the second shield image from the left.

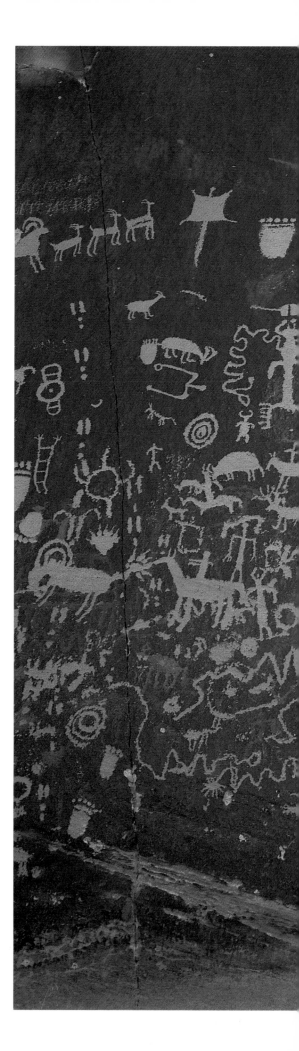

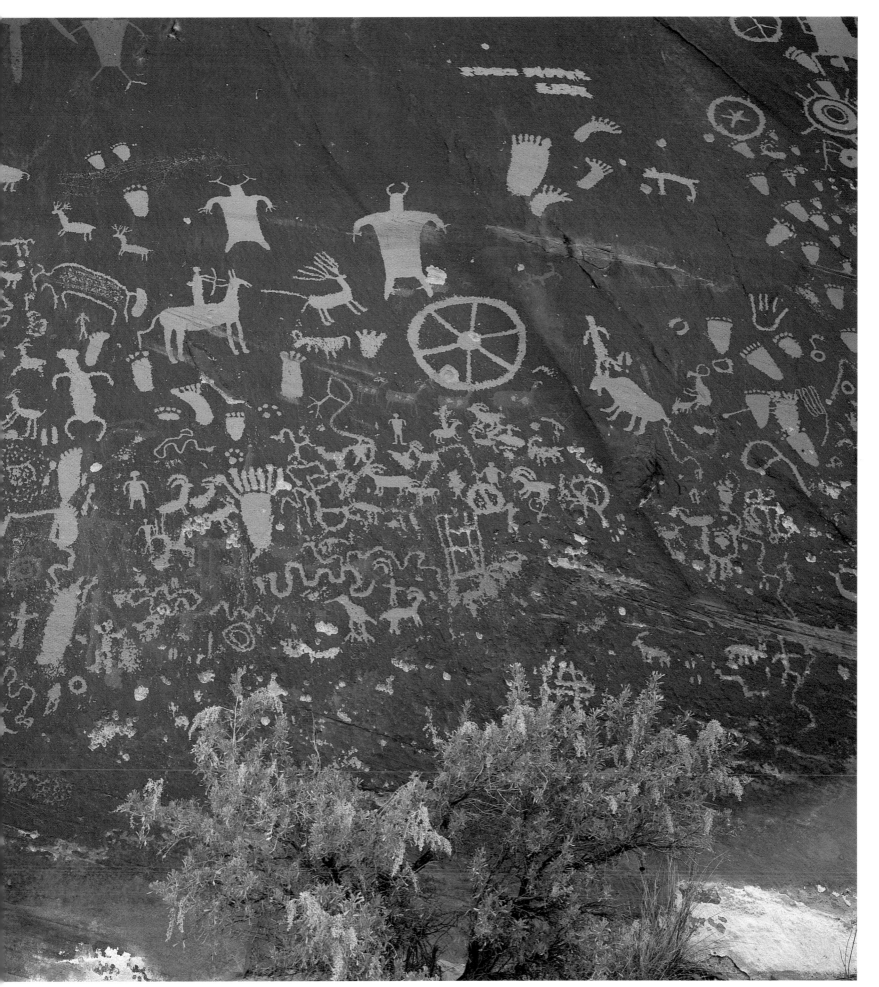

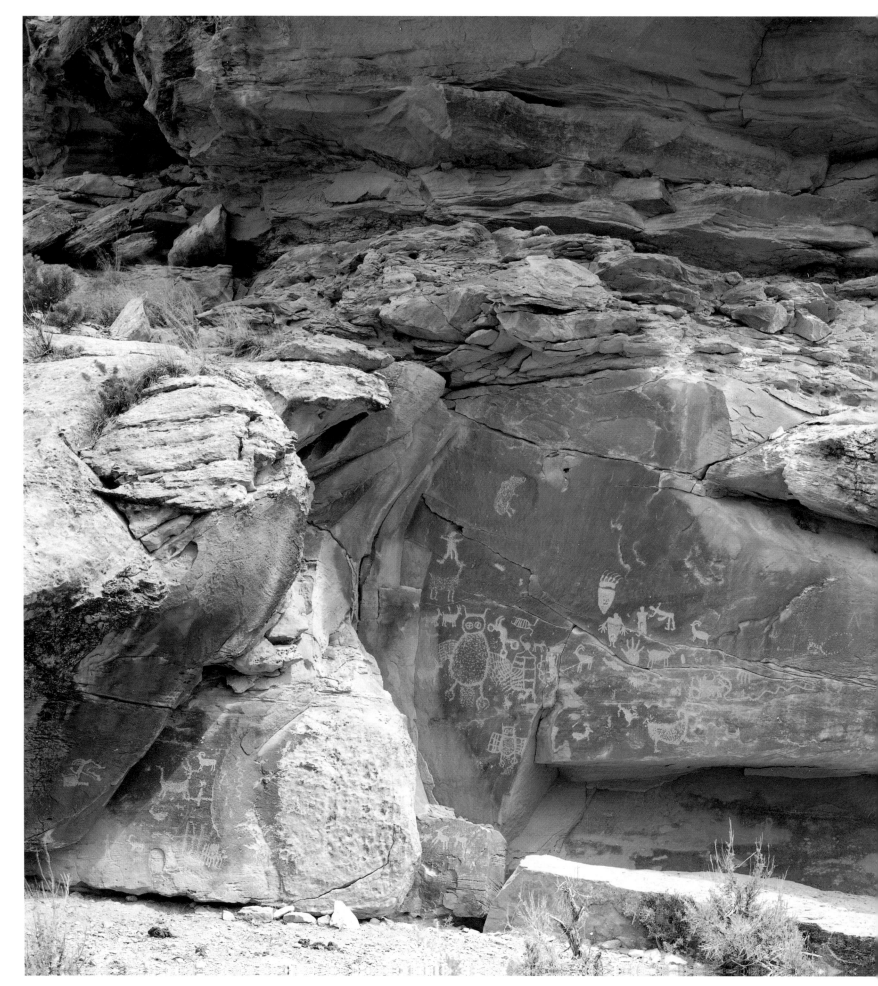

Plate 54

Owl Panel, Ute, Nine Mile Canyon,
John Telford.

Owl and large bird images are
common in Ute art. The detailed bear
footprint is also frequently seen at
Ute rock-art sites.

Through my job as a BLM archeologist, I've had the opportunity to work with volunteers who have walked practically every canyon in central Utah and they told me about the vandalism that's occured there over the last thirty years. Many rock art sites along the highway, which is Redwood Road as you leave Salt Lake City, were destroyed when that road was built. The petroglyphs were just blown to pieces. Other rocks in the area were removed. Where there were 200 locations at the time of contact with Euro-Americans, there are now maybe 100 locations. Some rocks that were moved are now at Brigham Young University. The majority are probably at private residences all over Utah.

Around the state, vandalism also goes on by people writing their names near petroglyphs, and chalking them with white chalk. That's destructive because the chemicals in the chalk speed up the rate of deterioration. Other petroglyph sites are in danger because of recreational tar-get shooting. People put cans and targets up against the rocks, and, as soon as the bullet hits, it puts new holes in it. Sometimes it cracks the rock. Sometimes it completely shatters the surface. Damage is also done by people going in with rock cutting saws. They are able to cut through the rock and remove the face of a panel. Depending on the quality of the picture, these panels can go for thousands of dollars on the black market.

Recently, in southern Utah, a new age Indian group was caught shooting arrows at panels as part of a ceremony. Each time an arrow hit, it knocked tiny pieces of rock off. I've also seen where vandals have dug holes under panels. This is a sensitive issue, because Indian people leave offerings of arrow heads, or bone heads, or money there because the rock has power, and they were asking this rock to help them. I've seen where people have dug under medicine rocks looking for this stuff. I don't know that this harms the panel, but when you leave an offering at a site, it's much like a burial. You don't desecrate burials, because once somebody is buried, it's forever considered sacred. Disturbing the burial makes the site dirty. It makes it unclean. It is like going into a church and stealing Bibles, or taking the offering money, or the priest's robe. It's sacrilegious, uncouth.

This is an estimate on my part. But based on visits around the state, I would have to say that as high as seventy percent of all Utah sites are damaged. In fact, if we look at northern Utah alone—Salt Lake, Ibapah, Duchesne, Utah Lake, Northwest Utah—the total rises to 95 percent. On Stansbury Island, 95 percent of the rock art has been removed. It's sitting in somebody's backyard. So it's a horrible problem. And our present budget is too limited to stop it or to even document the remaining sites. Whatever has been done to document or safeguard these sites has come through the resources of people who consider these images so significant, so irreplaceable, that they go out and do it themselves.

MELVIN BREWSTER
NORTHERN PAIUTE

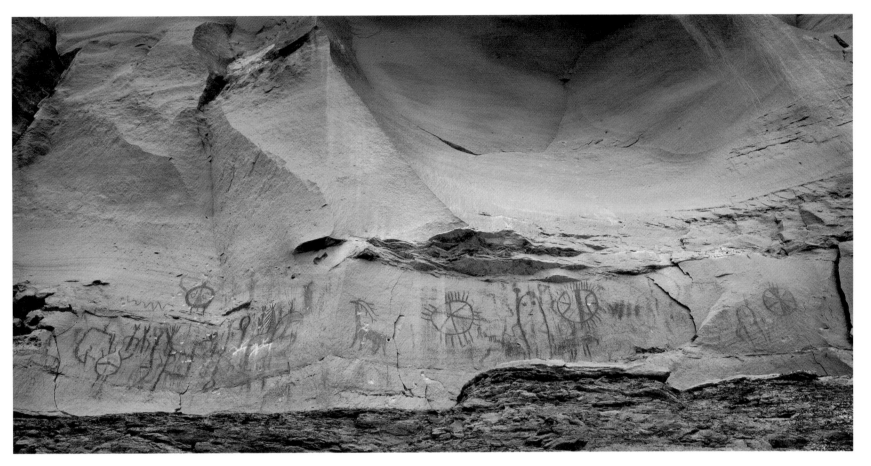

Plate 55
Long Panel, Ute/Fremont(?), Book Cliffs, Craig Law.

This unique panel, about 80 feet long, was created by wetting large chunks of red ochre, found in the formation directly underneath the panel, and drawing directly on the canyon wall. The shield figures bear stylistic associations to Fremont images.

Plate 56
Three Shields, Ute/Fremont(?), Book Cliffs, Craig Law.
Painted in red and white on a delicately colored sandstone wall, these images
have already lost their lower sections to weathering.

It must have been in 1983 or 1984. We were working with LaVan Martineau [to make a film on Ute rock art]. He came out and we set up a week-long shooting schedule to film different areas on the reservation. We drove down, south of Ouray. I can't remember where exactly, but LaVan had concise notes. [In fact] I was amazed by his looseleafs. He had four notebooks and each one had diagrams of the drawings; he called them panels. At the top of each page, he had an illustration; underneath, he had his interpretation and [the] location. It was amazing.

When we came upon the first panel, we hauled our equipment up and set up to video tape. It must have been around noon when we got there. We thought, okay, we'll get one [panel] done, then we'll have lunch. We powered up our cameras and equipment and nothing came on. I thought, wait a minute, we charged the batteries.

There should be no reason—we were getting low battery level readings. Our cameras would come on and then—poof—they would go off. I said, okay, let's have lunch and think about it. We started to eat and got to thinking and talking about it. And [what turned it around] for me was realizing that the people who put these stories on the rocks are no different than me when I produce a video. They were storytellers in their own right. But they used the rocks. And just as I pray over a production before I start, asking that it be something positive, they probably did the same thing.

I saved a bit of my sandwich and a few chips, and, after I finished eating, I went out to pray and talk to them. I said, "I really don't understand everything. I'm a man of this time. You are from another time, and you left this story on these rocks. I want you to know I am not here to take it and sell it. I want our kids to understand what it is you wanted to say. Here is a man [with us]. It has worked out to where we are here together to tell your story, so use us and [use] this technology to tell your story."

When I pray I close my eyes and go to a place I am used to that I can communicate [from]. So I shut out everything that was around me and concentrated on what I was saying—but the others told me a whirlwind came up and it was going around me while I prayed. I had part of this sandwich and chips in my hand and I gave it as an offering, then the whirlwind left. After I finished, we went back to see if there were other batteries [in the van], and all of a sudden I saw that the batteries that were dead were up, and we had no other problems.

LARRY CESSPOOCH
NORTHERN UTE

I dreamt that my nephew and I were consulting with the Utah Goshute Tribe. My nephew is one-fourth Indian and he is not dark complected. To look at him, you would never know he is Native American. Anyway, we were trying to protect petroglyph sites from being destroyed by a development project. I was working to inform the tribe about federal laws they could use to protect them.

We were riding in a dune buggy when the dream switched to my nephew, myself, and the tribal people standing inside the *Enola Gay* hanger in Wendover. The *Enola Gay* is the airplane that dropped the atomic bomb on Hiroshima. We were inside the hanger, drinking beer, and building fires. Indian people were all around, standing by their fires. We looked at the way we made our fire and thought: Is this the way they used to make fires? We looked at their fires and we thought: Wow, they make fires the same way.

The dream shifted to Indian people standing in traditional regalia by the fires and singing Indian songs. The next thing I knew, we fell into the earth. We fell inside the ground. I remember thinking: Am I ever going to get out of here? Finally, we came out of the ground, and the Indian people had all turned into skeletons. But they were still singing and dancing around the fires.

We then got back into the dune buggy and drove by the rock art sites. There was a creek and all this varied rock art. Each panel had a different meaning, and the meanings had to do with the earth. And if this rock art were damaged, it would cause irreparable harm to the earth and the way the earth functioned. One panel showed why the earth's heart beat. One panel had to do with the earth's blood.

When you looked at these panels at night, they turned fluorescent green and they said: "I know you don't believe what I am telling you. But these rocks are showing you that what I am saying is true." Each panel, as I said, explained the way the earth functioned: one had to do with the earth's heart, one the kidneys, one

the blood. And that's why they were sacred. That's why they were here.

They said to me: "Be good to your nephew. Listen to him. He knows the ways of the old people." Then the dream switched to us driving up a hill in the dune buggy. We knew if we did not get to the top of the hill, the development would destroy these sacred petroglyphs. Suddenly, the dune buggy flew over backward. Everybody in it fell into water. I landed at the middle of the hill, and something told me to run as fast as I could up the hill. I ran to the top. Do you know who was waiting there for me? My nephew and the Indian people who fell into the water. We got to the top of the hill and I woke up.

MELVIN BREWSTER
NORTHERN PAIUTE

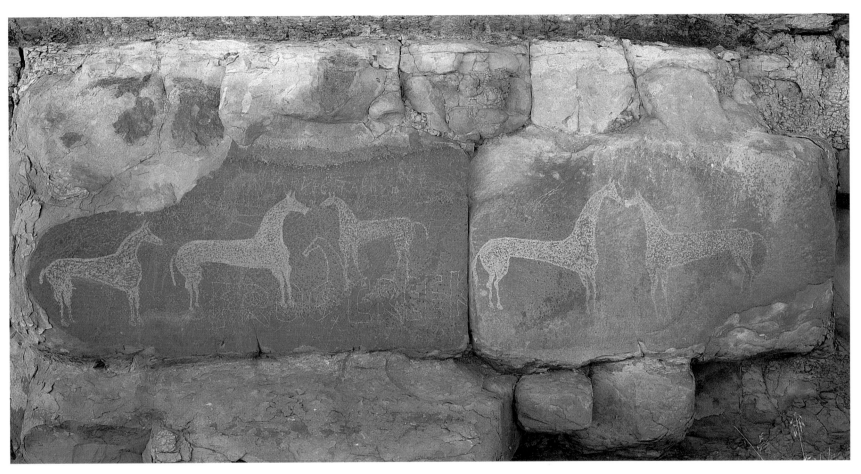

Plate *57*

Horse Panel, Ute, Uinta Basin, Craig Law.

In spite of recent graffiti, these carefully articulated horses continue to hold themselves with
an air of Old World classicism. The figures are less than three feet in height.

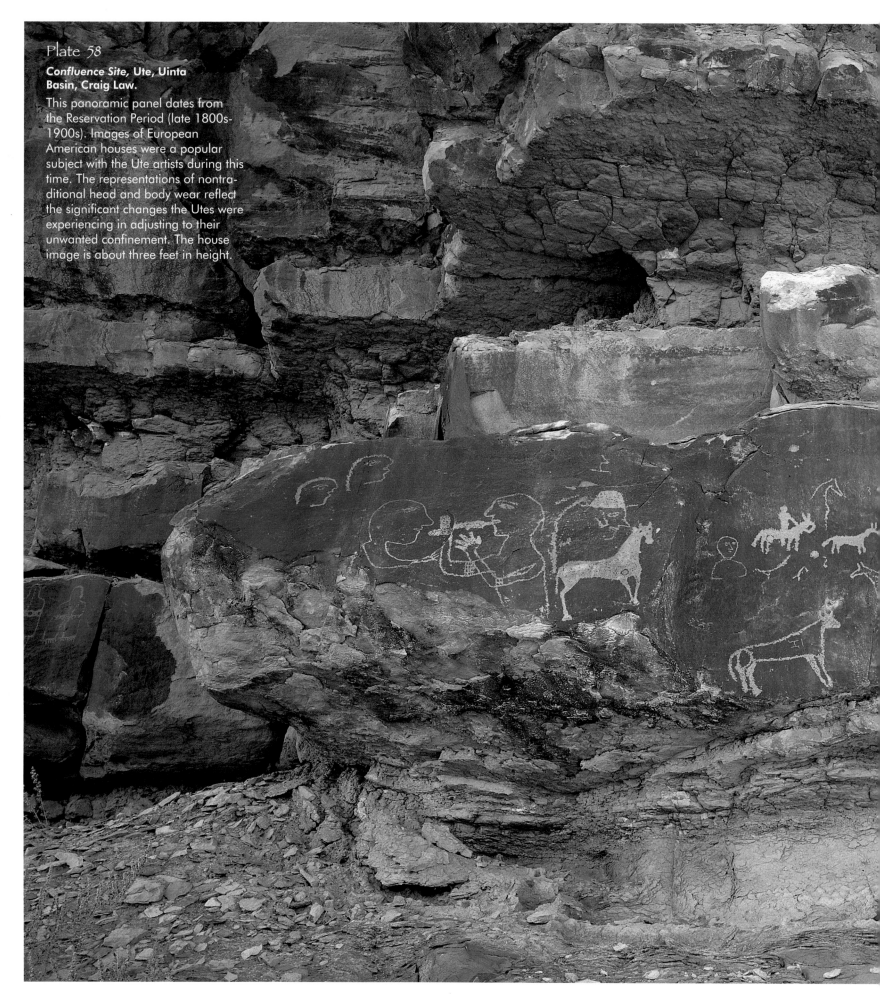

Plate 58

Confluence Site, Ute, Uinta Basin, Craig Law.

This panoramic panel dates from the Reservation Period (late 1800s-1900s). Images of European American houses were a popular subject with the Ute artists during this time. The representations of nontraditional head and body wear reflect the significant changes the Utes were experiencing in adjusting to their unwanted confinement. The house image is about three feet in height.

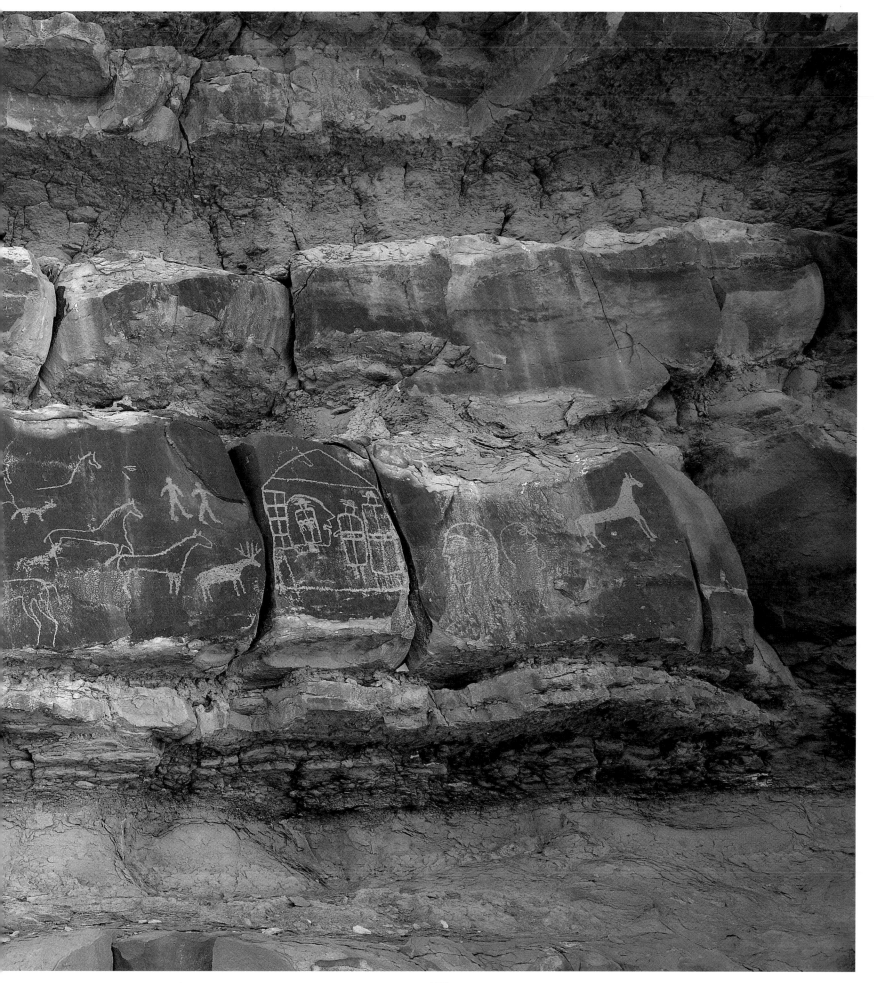

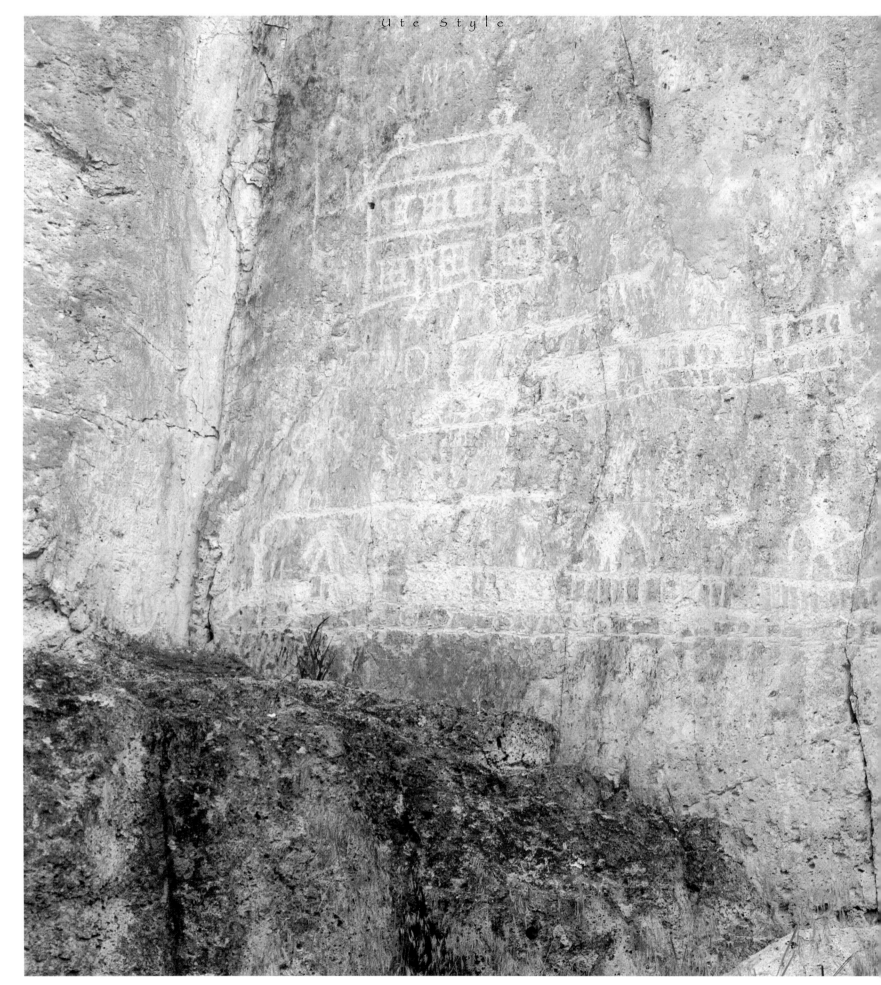

Plate *59*

***Train and House Panel,* Paiute/Ute(?), Fremont Indian State Park, John Telford.**

It has been reported that this panel was created by a local Paiute. The subjects, imagery, and execution are remarkably similar to the Ute panels in the Uinta Basin. Notice the two-sided representation of the house in the upper left.

When I was a kid, I saw the rock art created during the [last] warrior period. It was probably put there soon after the 1881 removal of the Utes from Colorado. It showed Indians on horseback, trains coming from Price, Utah and Grand Junction, Colorado. This was all really new to the people so they would draw it on the rocks. The other things I saw were houses and a cowboy holding up another cowboy—a man with a gun pointed at another man who had his hands up. That's the kind of rock art I could definitely say was Ute.

ROLAND MCCOOK

NORTHERN UTE

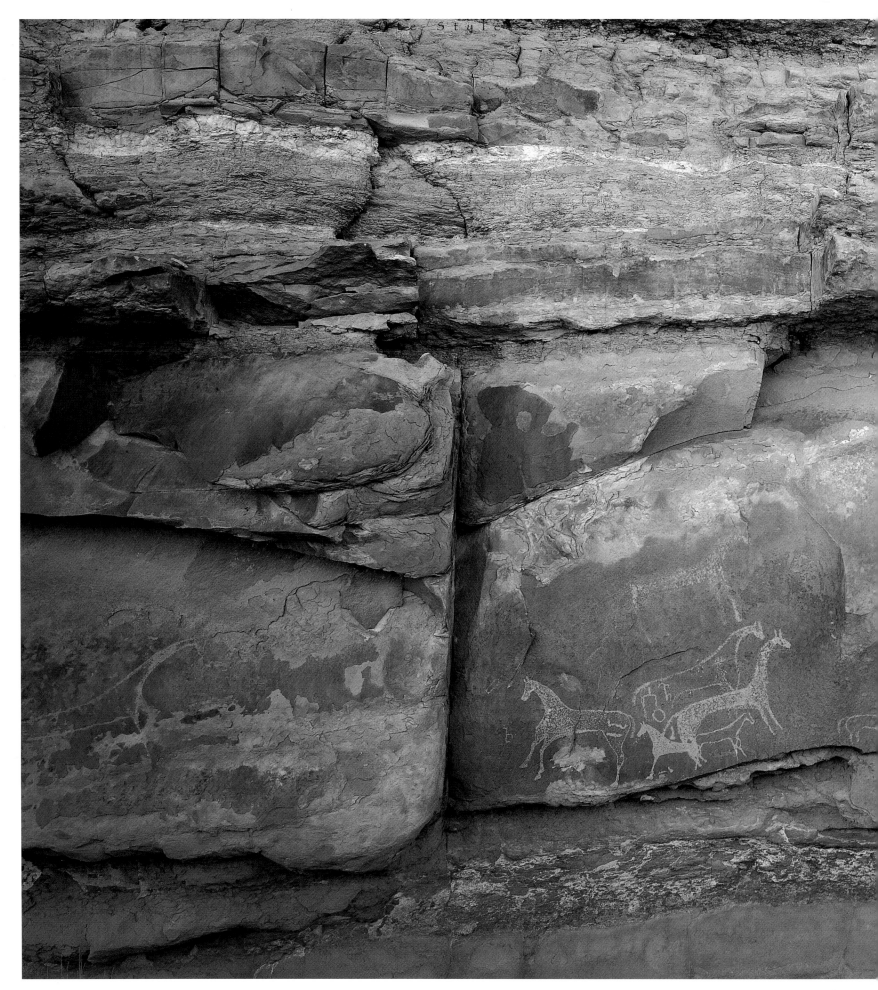

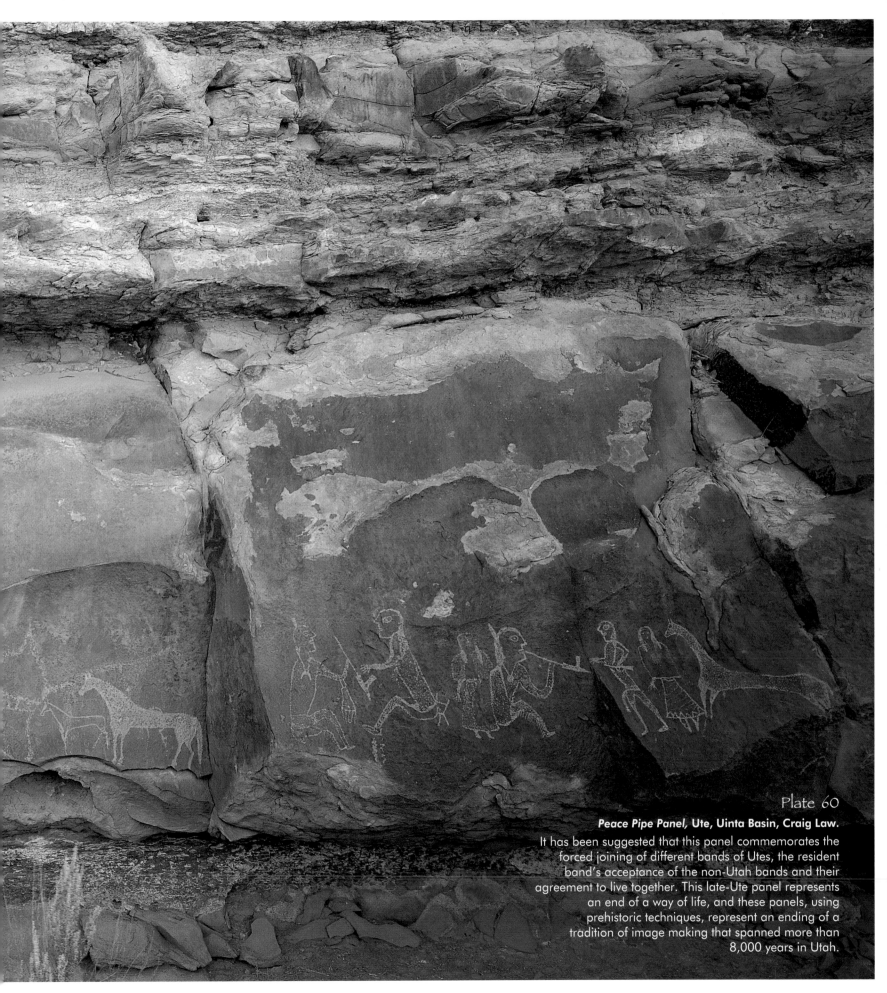

Plate 60

Peace Pipe Panel, Ute, Uinta Basin, Craig Law.

It has been suggested that this panel commemorates the forced joining of different bands of Utes, the resident band's acceptance of the non-Utah bands and their agreement to live together. This late-Ute panel represents an end of a way of life, and these panels, using prehistoric techniques, represent an ending of a tradition of image making that spanned more than 8,000 years in Utah.

Storytellers are blessed with an ability for the Creator to use them. They have to have a mind open to that. And if you've been blessed with these abilities, then it is up to you to develop them to where they will be useful to you and your people. A good storyteller says things that will stick with you, and maybe forty, fifty years down the road—boom— you'll remember what was said and for an instant you'll realize what he meant. That's the power of the storyteller. It's the ability to reach another person, not necessarily human either, and to communicate a message. I say it this way because I don't know if he is a storyteller or a spiritual person who understands how this works and knows how to ask for guidance and direction to relay this.

In the case of the rock writing, the [ancient] storyteller didn't find any rock and start to work. He knew what he was going to say, then found the *right* rock. And I believe in finding this rock he would ask [the Creator] for direction. Like any of us, we'd be driving along the road and say, "It's right here somewhere. I sense it's right here where I should do this." You go to the next cliffs and rocks and suddenly realize—right here, this is the one. Then you would tell your story on that rock. But the thing to remember is that these rocks are no different than us human beings. They have a purpose, too, and that rock said to him: "I am the one." And the storyteller had to be open to that. The same way he received his stories, he had to be aware of that.

There are some flat rocks that are natural canvases. But there are others where the formation of the rock added to the story. In this panel where the storyteller shows that the Uncompahgre and White River bands were relocated to Utah, and that a pipe was used amongst all three groups to bring them together, he started on a higher point on the panel to illustrate Colorado and its higher hills and to show that they came down to flat lands where the Uinta figure is. So even the cracks in this rock have meaning. The photograph, of course, will only present a portion of this meaning. The other portion is the physical presence of the rock, which is as alive as you and I. And I don't know how you'll get the impact that you would if you were standing looking at the magnificence of the panel and the rock itself. But what I would suggest is that you talk with them, ask them to help you tell their story. Then I think that will be there, 'cause these storytellers will help you any way they can. Because [in presenting their stories] you are bringing *all* these forces together. And that's where the impact of this experience is. And as long as you ask for something positive, that's what you will get.

LARRY CESSPOOCH
NORTHERN UTE